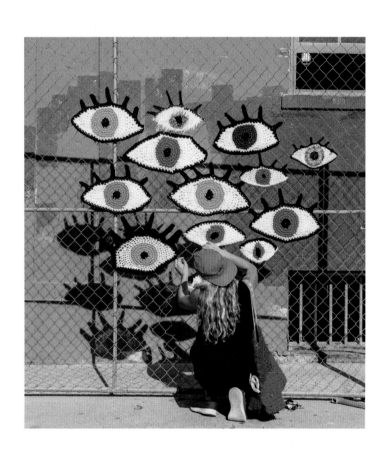

Crochet

with London Kaye

PROJECTS AND IDEAS TO YARN BOMB YOUR LIFE

ABRAMS, NEW YORK

Editor: Meredith A. Clark
Designer: Danielle Youngsmith
Production Manager: Kathleen Gaffney

Library of Congress Control Number: 2018958785

ISBN: 978-1-4197-3807-4
eISBN: 978-1-68335-671-4

The material contained in this book is presented only for informational and
artistic purposes. The publisher and author do not condone or advocate in any
way illegal activity of any kind. If you engage in any illegal activity, you are
doing so at your own risk. The author and publisher do not accept liability for
any injury, loss, legal consequences, or incidental or consequential damages
suffered or incurred by any reader of this book.

Printed and bound in China

10 9 8 7 6 5 4 3 2 1

Abrams books are available at special discounts when purchased in quantity
for premiums and promotions as well as fundraising or educational use.
Special editions can also be created to specification. For details, contact
specialsales@abramsbooks.com or the address below.

Abrams® is a registered trademark of Harry N. Abrams, Inc.

ABRAMS The Art of Books
195 Broadway, New York, NY 10007
abramsbooks.com

This book is dedicated to my sister, Chase. She is there for me today and has been there for me every day for the past twenty-seven years. I have built a business crocheting from the ground up, and none of it would have been possible without my sister. She is my biggest cheerleader and is always there with profound advice that is wise beyond her years. Some of the times I will cherish most are the years we lived together in New York City, working together on crochet projects around the world.

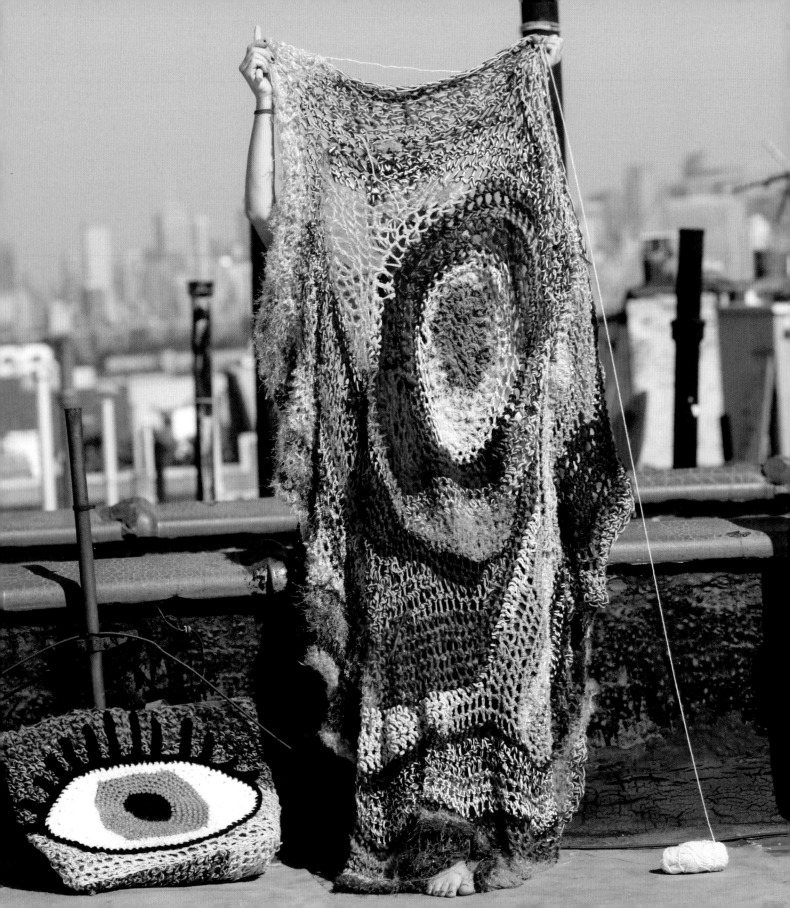

CONTENTS

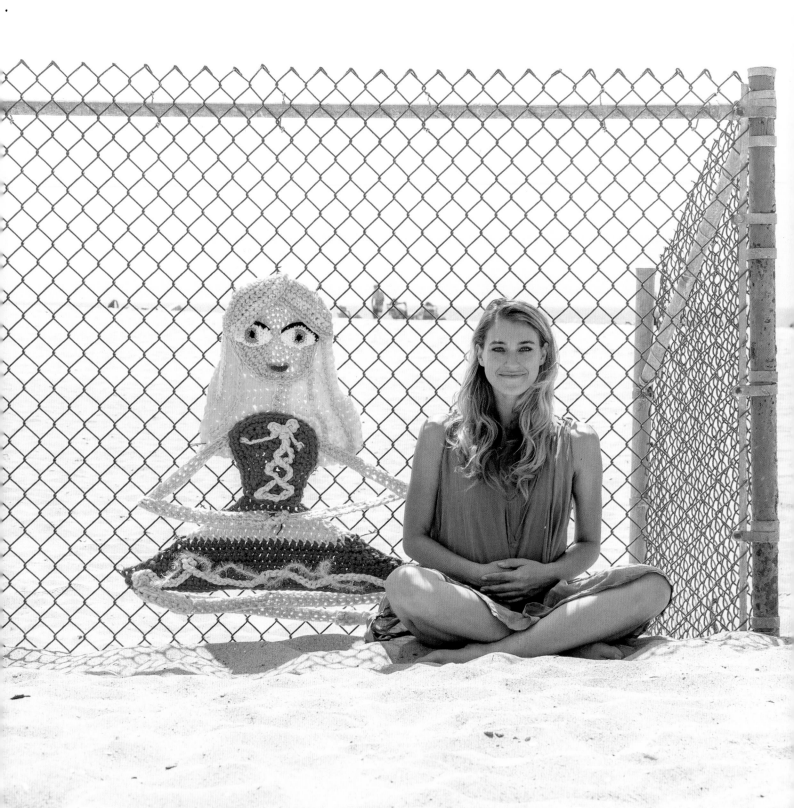

INTRODUCTION

I'm always excited to meet someone who has a relationship with crochet. Whether it is a sweater passed down from generation to generation or a blanket made specially by a loved one, yarn has always been there to bring people together—or, at the very least, to make them smile. But the world of yarn is changing. Crochet is no longer your grandmother's sport. It's coming back in style, and I consider myself lucky to be a part of this exciting revolution.

In the summer of 2013, I was working at an Apple Store in the hub of New York City, where the world's hippest, trendiest, and most artistic dwell. The work could get monotonous, so I kept myself entertained by engaging with the eclectic group of customers who came into the store. One day, a woman by the name of Olek walked in with a crazy crocheted bag. It was unlike anything I had ever seen.

I was enamored of her bag and wanted to know more. Right after she left the store, I went to a computer and googled her. The results not only showed me more about the artist, but a few of the top hits also showed me

more about yarn bombing. Not much had been written on yarn bombing at the time, but I gathered it was the practice of wrapping a piece of crocheted or knitted fabric around an object in a public space. The idea was to make people happy and to encourage them to think about yarn in a new way. Although I grew up crocheting, I had never considered using yarn to make anything other than a typical scarf or blanket. This was my pivotal moment.

Within seconds, I was opened up to an entirely new way of crocheting. I fell in love with creating crazy things out of yarn. I wasn't yarn bombing with a specific goal; I just wanted to put my crochet art out on the street and, hopefully, make someone's day (just like that bag had made mine). I gave myself the freedom to create my own style and veer from traditional yarn bombing, if there even was such a thing. I began using chain-link fences as my canvas and layered shapes on top of one another to create an even bigger picture. I soon developed my own technique.

It's been only five years, but I have accomplished so much more than I could have previously imagined. Yarn bombing has become my full-time job. I've had my work sold at ABC Carpet & Home. I've had a couture capsule collection with REDValentino and made a fifty-foot billboard entirely of crochet in Times Square. I've yarn bombed entire coffee shops. A mix of hard work, determination, luck, and a whole lot of yarn has led me on this incredible journey.

I was born in Los Angeles to an artist mother and a musician father. Both of my parents appreciated the arts and raised my sister and me to follow our artistic passions. For the longest time, dance was mine. I spent countless nights at my studio, dancing until my feet were blue. The intense work led me to suffer a back injury at age thirteen, which put my dance career on hold. For someone who found solace in keeping busy, being on bed rest was not an ideal situation. As luck would have it, my friend's mom taught me how to crochet one summer afternoon, and that was it: I was hooked (pun intended). It started out as a hobby but soon transitioned into my first business.

I started selling custom scarves to the girls at my dance studio. I called my business Spectacular Scarves. By the time I was sixteen, I had earned enough money to buy my own car. Eventually I was able to dance again, and my little crochet business fell by the wayside. I studied dance at New York University, where I was fortunate enough to receive a full scholarship and put all my attention into ballet—until graduating, when I found myself at a crossroads yet again. I knew I wanted to do something creative, but I wasn't sure anymore if it was dance. Dance had always been my passion, but it was not necessarily how I wanted to make a living. While I grappled with the daunting question of what I wanted to do with my life, I started working at the Apple Store. But it didn't take long for me to realize I wanted something more—something out of the ordinary, adventurous, and creative. When you are clear on what you want, the universe tends to reward you with little signs.

After that initial introduction to yarn bombing, I began my self-imposed thirty-day challenge. Every day I found inspiration for what to crochet, and every night after work I put up a yarn bomb. I had no previous yarn bombing experience, but I knew how to single crochet, and that was all that mattered. I love a challenge. Even if I don't have the time, I'll make it happen. And instead of putting up a yarn bomb every day for only thirty days, I did it for fifty. This daily practice helped me develop my unique style. There are only so many objects you can wrap in crochet, so I had to branch out. I found new and unique ways to display my pieces. All of a sudden, that spark of passion was back in my life. I had always loved to crochet, but now that I was crocheting on new surfaces, I was able to explore my creativity in an entirely new way.

The street-art scene in Brooklyn inspired my work and laid the foundation for developing a new type of street art that didn't hurt the environment. "Soft graffiti" is the term I like to use. I loved seeing people walking down the street and encountering my work. My art brightened their day, and their joy brightened mine.

I tagged each piece with my Instagram handle, and soon big companies started commissioning me to create pieces for installations, ads, and campaigns. I needed no publicity; yarn was my business card. And that is how I started my second crochet business. I hesitated at first, but I realized if I could do it at thirteen, I could certainly do it now. I've learned that when you jump, those are the moments when your life begins again.

There still hasn't been much writing on yarn bombing. I am asked all the time to give tutorials on how to create the pieces I make. That's why I'm excited to share this book with you. First, I will walk you through the basics of crocheting. Then, I will teach you yarn bombing projects you can make for your home, projects you can adorn the street with, and projects for your own personal flair. I realize not everyone has the time to crochet billboard-sized projects, so there are ideas of many sizes that even a first-time crocheter can complete. I suggest colors, but please feel free to go with whatever your heart desires. Sometimes my best work comes from an accidental slipup.

I am inspired by everything and everyone I encounter each day. I spend a lot of time looking at pop culture, fashion, interior design, and art for inspiration. My style of yarn bombing is not precise couture work. It is organic and free-form and meant for the street. It has irregularities and flaws, just as we all do. Yet it is bright, eye-catching, and happy. It is my simple way of trying to make this earth a better place to live. I try to create something new every day, and I encourage you to do the same. So without further ado, let's begin!

CROCHET 101

how to crochet

rochet is a chain of knots that moves from right to left, then turns at the end of the row. This process is repeated until the project is complete. There are a few exceptions to this movement, such as when working in a circle or on something abstract.

POSITION OF THE HANDS

You can hold a crochet hook a few different ways. You will need to experiment with the position of your hands until the hook feels comfortable. If your hands are tense, your stitches will be uneven.

Hold a crochet hook between the thumb and index finger of your dominant hand, and guide the hook with the middle finger. Your other hand holds and controls the yarn. After a little practice, your hands will assume the proper position automatically.

HOW TO CHAIN

Every crochet starts with a foundation chain. The length of the foundation chain depends on what you are making.

Make a slip knot: Pull about 8 inches (20 cm) of yarn off your skein. Wrap the tail end of the yarn around your index and middle fingers. Continue to pull the yarn through the loop, stopping before the entire tail comes out. (**PHOTO A**)

Hold the slip knot in your nondominant hand, and insert the crochet hook in the slip knot from front to back.

Move the tail end of the yarn into your dominant hand while keeping the working yarn in your other hand. (**PHOTO B**)

Wrap the working yarn over the hook from back to front. These wraps are called "yarn overs." (**PHOTO C**)

Turn your hook about ¼ inch (6 mm) so you catch the yarn with the hook, and pull it through the loop. You have made your first chain. (**PHOTO D**)

To add chains, repeat as needed. Practice making a chain until it feels natural and your stitches are even and not too tight.

HOW TO SINGLE CROCHET

The single crochet is the most basic crochet stitch.

Crochet a foundation chain. You will work your first row of single crochet stitches into this foundation chain. (**PHOTO E**)

Hold your foundation chain and your yarn in your nondominant hand, and slide your hook from front to back into the second chain from the hook.

Wrap the working yarn over your crochet hook from back to front and catch it with the hook. (**PHOTO F**)

Pull the hook and the yarn through the first loop so you have two loops left on your hook. (**PHOTO G**)

Wrap the working yarn over your crochet hook again from back to front. (**PHOTO H**)

Pull the hook and the yarn through both loops so you are left with one loop on your hook. This completes a single crochet stitch. (**PHOTO I**)

Make one single crochet stitch in each chain stitch until the row is complete. (**PHOTO J**)

Turn. Keep the last loop on the hook, and rotate your crochet work counterclockwise. Move only the crochet work, not the hook. Use this technique every time you turn your work.

Make one single crochet stitch in the first stitch of your crochet work and in each remaining stitch in the row.

Repeat steps 8 and 9 until you feel comfortable with the single crochet stitch. (**PHOTO K**)

HOW TO FINISH OFF

When you finish crocheting, you will need to secure the crochet loops so they do not unravel. To finish off, cut the working yarn about 4 inches (10 cm) from the crochet work and pull the crochet hook up until the yarn end pulls through the loop. You can then weave the extra yarn through the crochet work until it disappears, or loop the yarn through your last crochet stitch to make a knot. Trim any extra yarn you see on your finished crocheted piece. (**PHOTO L**)

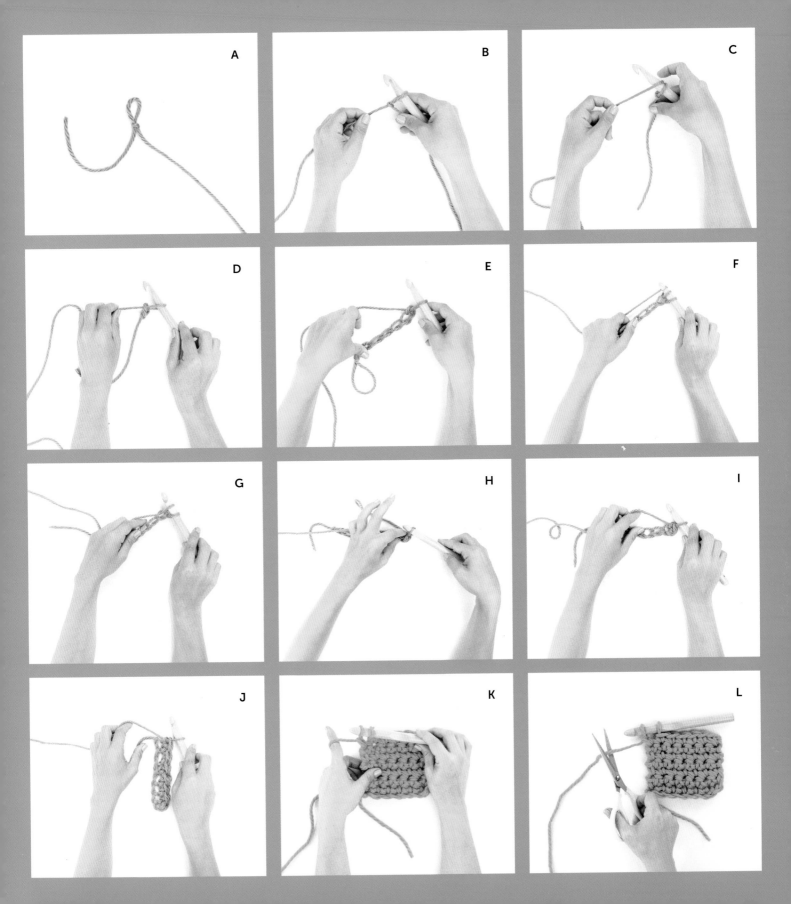

A

B

C

D

E

F

G

H

I

J

K

L

A

B

C

D

HOW TO CHANGE COLOR

You can change the yarn color you are working with at the end of a row or whenever inspiration strikes. My favorite way to change the yarn color as you work is to use scissors to cut your working yarn a few inches from the crochet hook (**PHOTO A**), then join new yarn by tying it to the old with a double knot. (**PHOTO B**) Trim all extra loose ends when you are finished crocheting the piece.

Another way to change the working yarn takes more practice but ultimately is a much cleaner method. Begin the last single crochet stitch, but when you get to the final yarn over, hook the new yarn (**PHOTO C**) and then finish the stitch. You may need to gently pull the yarn ends together to keep the loops from getting too big. Cut the original working yarn after you complete the stitch (**PHOTO D**) if you will not be using it again within the next few rows. This technique works great when you are crocheting stripes.

tip

Sometimes I change color when a skein of yarn happens to be done; other times, I do it when I feel that the time is right for it.

tools and supplies

CROCHET HOOK

A crochet hook is one of the most important parts of the art of crochet. In many ways your hook is like a paintbrush, as it is the vehicle that allows you to transform a skein of yarn into something that previously existed only in your imagination. The crochet hook dates back to the eighteenth century, when crochet was born. Hooks have continued to evolve throughout the ages. The first crochet hook was the index finger, and hooks have been made from hardened mud, mother-of-pearl, copper, ivory, bone, and other natural materials. Nowadays hooks are largely made from plastic, aluminum, steel, and wood. Crochet hooks come in a variety of sizes, ranging from tiny hooks used for making lace to large hooks used for yarn bombing. Bigger hooks allow you to finish projects more quickly while still maintaining the nostalgic feel of your grandmother's crochet.

Choosing the right hook is important. A crochet hook should be comfortable to hold and should slide between loops easily. Selecting the right hook depends on the yarn you choose and the overall size of the project. The bigger the hook, the larger the crochet loops will be.

My 3-D-Printed Crochet Hook

I have always had a passion for crochet hooks, so I used 3-D modeling and printing technology to create the perfect crochet hook. I tested endless designs until I came upon the one that had everything. This 3-D-printed crochet hook combines all of the most important features needed to crochet comfortably and efficiently.

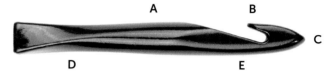

Parts of the Crochet Hook

A: Twisted thumb rest

B: Long hook

C: Point/*spitze*

D: Short handle

E: Lightweight shank

OTHER TOOLS

Scissors: to cut yarn and loose ends

Hot glue and glue gun: to glue crochet elements together

Sewing needle: to sew crochet elements together

Adhesive spray: to adhere crochet elements to fabric

Measuring tape: to measure crochet elements and objects

Safety pins: to mark crochet work in progress

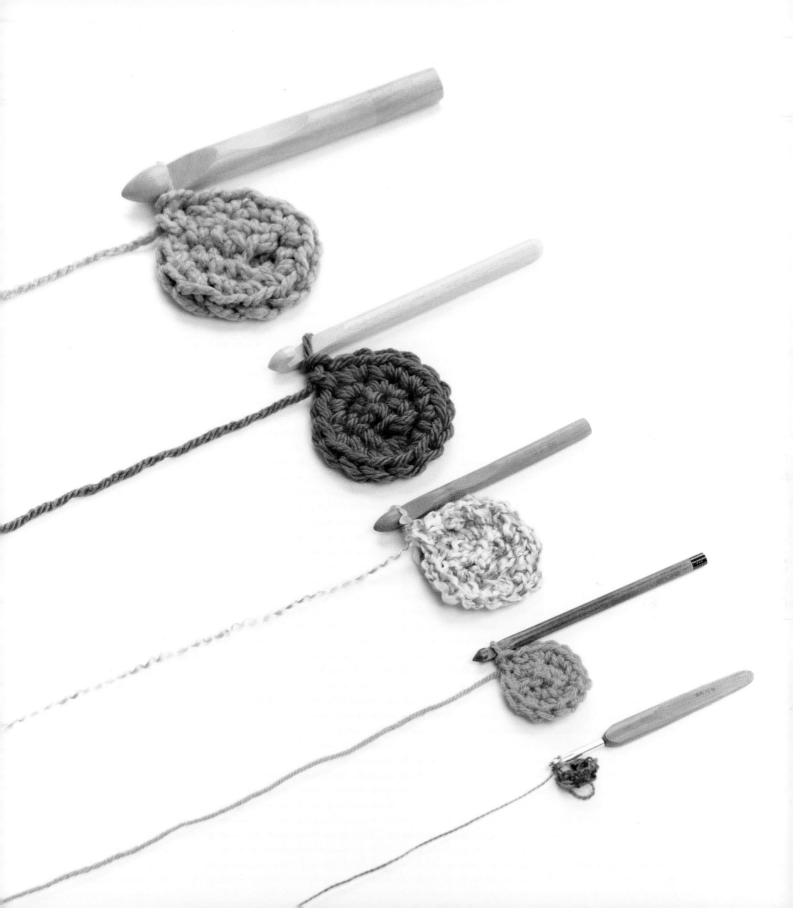

yarn

Yarn is made by spinning short fibers together to create long strings. There are so many different kinds of yarn, including cotton, wool, and acrylic. Acrylic yarn works best for yarn bombing because it is durable and comes in a multitude of vibrant colors, textures, and weights. Yarn weight refers to the thickness of the yarn. This is an important factor to consider when choosing yarn for a particular project. Bulky yarns are best with a large crochet hook because they work quickly and have a cozy feel. Medium-weight yarns are the most versatile. Light-weight yarns produce a lacy look and are good for experimenting with a small crochet hook. Unusual novelty yarns are exotic, and you may not be able to purchase them in bulk. Use these yarns to add details, or combine them with another weight of yarn to create a one-of-a-kind combination.

SELECTING YOUR YARN

Before running off and buying yarn for a project, go into your yarn stash and pull out everything that catches your eye. Sometimes you create the best crochet pieces when you are constrained in yarn choices. All of the projects in this book give you the freedom to mix and match yarn colors as you go.

You will find a number on almost every ball of yarn categorizing it as a particular weight.

0: Lace	**4:** Medium
1: Super fine	**5:** Bulky
2: Fine	**6:** Super bulky
3: Light	**7:** Jumbo

DOUBLE STRANDING YARN

Double stranding yarn is a technique for combining and crocheting with two different strands of yarn at the same time. Double stranding yarn adds dimension to your crochet piece because it mixes two weights and two colors. I double strand yarn almost every time I crochet with a 20 mm hook because it helps the crochet loops hold their shape better.

Do it! Go into your stash pile and pick out two random skeins of yarn. Try crocheting and double stranding the yarns. Play around with hook sizes and yarn weight combinations and see what discoveries you magically stumble upon.

tip

If you want to use a large crochet hook and do not have any bulky yarn, use the double stranding yarn technique (above) to make your own. If you want your yarn even bulkier, try triple stranding!

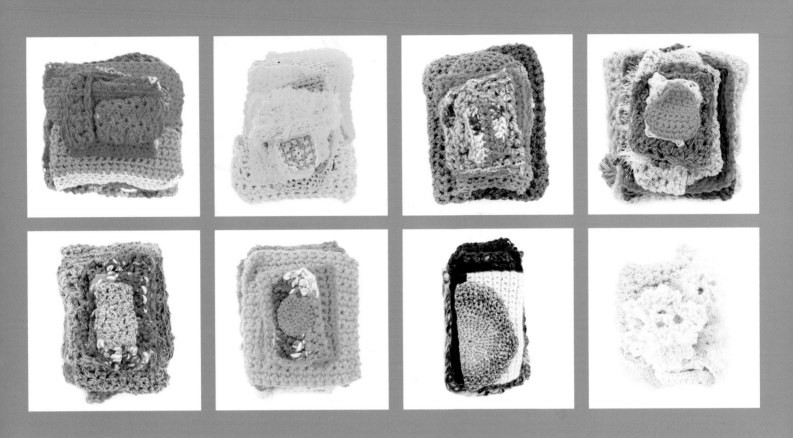

SELECTING YOUR COLOR PALETTE

Selecting a color palette is one of the most enjoyable and important parts of every project. By picking and sticking to a color palette, you guarantee the finished crochet project will have color continuity. Without even crocheting a stitch, you are off to a good start! My favorite way to pick a color palette is to find inspiration in the world. I am constantly taking pictures of beautiful, eye-catching moments and looking through magazines and old photos.

Look at a traditional color wheel and pair the complementary colors. Use colored pencils to design different combinations until you are happy. A good color palette for yarn bombing has between three and six colors. Sometimes I make my palette all one color and use a variety of shades to keep it interesting.

Color Palette Inspiration

Red: energy, power, passion

Orange: joy, enthusiasm, creativity

Yellow: happiness, intellect, energy

Green: ambition, growth, freshness, safety

Blue: tranquility, confidence, intelligence

Purple: luxury, ambition, creativity

Pink: playful, romantic, charming

Black: power, elegance, mystery

White: cleanliness, purity, perfection

glossary

Change yarn: Begin working with a different yarn

Color palette: The range of colors used in a visual medium, in a picture, or by an artist

Crochet: A handcraft in which yarn is made up into fabric by looping yarn with a hooked needle

Crochet hook: A needle with a hook on one end

Double stranding yarn: Combining and crocheting with two different strands of yarn at the same time

Finish off: To fasten off the yarn and secure it so the stitch will not unravel

Foundation chain: A series of stitches beginning with a slip knot

Loop: A length of yarn crossed over itself

Round: The series of stitches needed to go one time around the perimeter of a crochet circle

Row: The series of stitches needed to make one line of the crochet fabric

Shade: Varieties of a particular color; paler shades have more white and darker shades contain more black

Single crochet: The most basic crochet stitch for making fabric

Slip knot: The type of knot used to start every crochet project

Skein: A length of yarn loosely coiled into a ball

Stitch: A loop of yarn resulting from a single movement in crocheting

Turn: To rotate your working crochet fabric counterclockwise on its axis at the beginning of the row

Working yarn: The yarn that is being manipulated while attached to the skein

Yarn bomb: To wrap a piece of crochet or knit fabric around an object; sometimes this is done in a public place and is considered a form of street art

Yarn tail: The end of the yarn that is not attached to the skein

Yarn weight: Thickness of yarn

how to read the projects in this book

MATERIALS

Below is a guide to follow when you are selecting a hook and yarn for a project in this book. I have listed suggestions under the materials title of every project.

US J/10 (6 mm) or smaller: lightweight

US K/10.5–N/15 (7–10 mm): medium weight

US P/15 (11.5 mm) or larger: bulky weight

tip

Use the "Double stranding yarn" technique (page 22) when you are crocheting projects that use a size S/35 or 20 mm hook. This hook works best when you use two working yarns at the same time. Also, double stranding yarn makes the weight of the yarn bulkier. With a 20 mm hook, the bulkier the yarn, the better the crocheted fabric will look.

CROCHET ABBREVIATIONS

Chain: ch
Single Crochet: sc

TECHNIQUES

To turn your work: Keep the last loop on the hook and rotate your crochet work counterclockwise. Move only the crochet work, not your hook. You will use this same technique every time you turn your work.

To increase: Work two single crochet stitches in the same loop and continue working. This will make the stitches curve outward.

To decrease: Skip a single crochet stitch, then continue working. This will reduce the number of stitches in the row by one.

To finish off: Secure the crochet loops so they do not unravel by tying a knot. Refer to page 16 for techniques.

To change color: Cut your working yarn and replace it with a new yarn. Refer to page 19 for techniques.

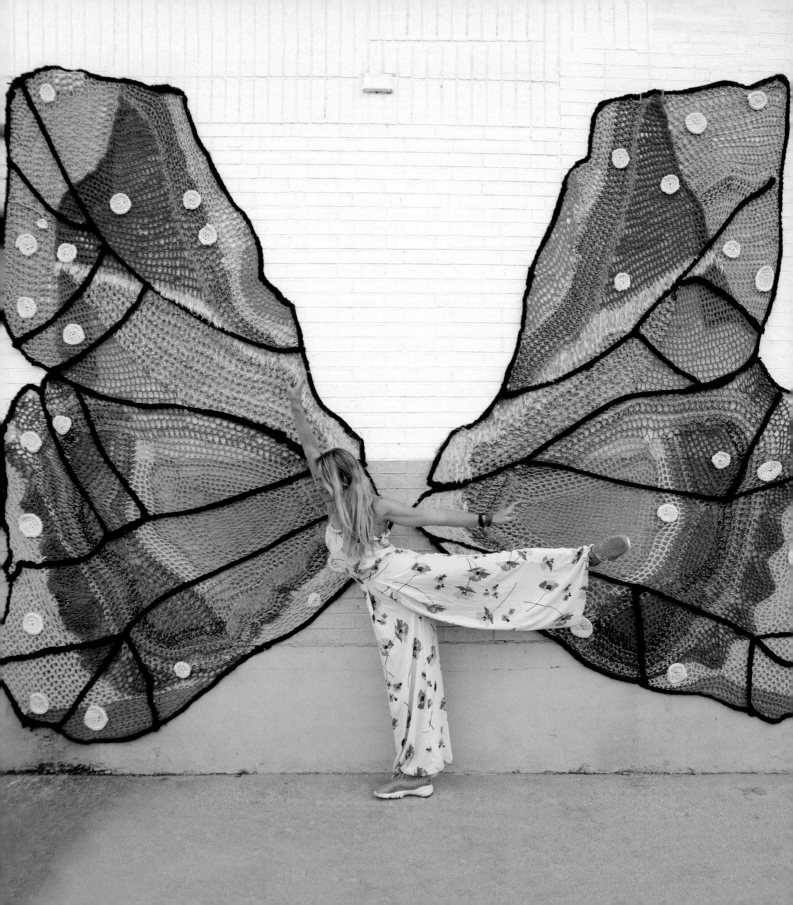

WHAT IS YARN BOMBING?

arn bombing is the act of covering objects or structures with crocheted or knitted material. Typically, yarn bombing is done in public places, but it can also be done indoors. I love yarn bombing because it is a way to bring unexpected joy to people's days.

techniques for yarn bombing

Yarn bombing is more than crochet. It also involves sharing what you crochet with the world. Here are some techniques that will help you do just that.

HOW TO MEASURE AN OBJECT OR SHAPE

A measuring tape is a flexible ruler. Use a measuring tape to determine how big or small something is. The way you measure an object depends on its shape.

Rectangle: Length and width

Circle: Diameter

Triangle: Base and height

tip

If you do not have a physical object to measure, lay the measuring tape on a flat surface and estimate the size.

Remember that crochet will stretch. After you take measurements, you may have to subtract a few inches from one of the dimensions to ensure your finished piece will be the right size. A finished crochet piece made with a large hook will stretch more than one made with a small hook, which produces a tighter crochet stitch that holds its shape better. If your final crochet piece does not fit because of the way it is stretching, undo your finishing row and add or subtract rows as needed.

tip

If the object you are yarn bombing is nearby, measure the crochet piece on the object as you work. This is the best way to ensure that your finished crocheted piece will fit.

WEAVE IT

This technique is used for traditional yarn bombing and works best for wrapping objects. Cut an extra-long piece of yarn at least twice the length of your finished crocheted piece. Double knot it to the top right corner of your crochet piece. Repeat the same thing on the top left corner. Now you are ready to yarn bomb.

Wrap your prepared crocheted piece around the object from back to front, and adjust the piece until you are happy with its fit. Tie the strings in a double knot at the highest point to secure the crochet piece into place. Then begin to crisscross the strings over and under each other, working your way in and out of the crochet loops the same way you would lace a shoe. When you reach the bottom, secure the weave with a double knot.

tip

If you run out of yarn before you finish weaving, double knot extra yarn to your string. Cut all visible loose ends when you are finished working.

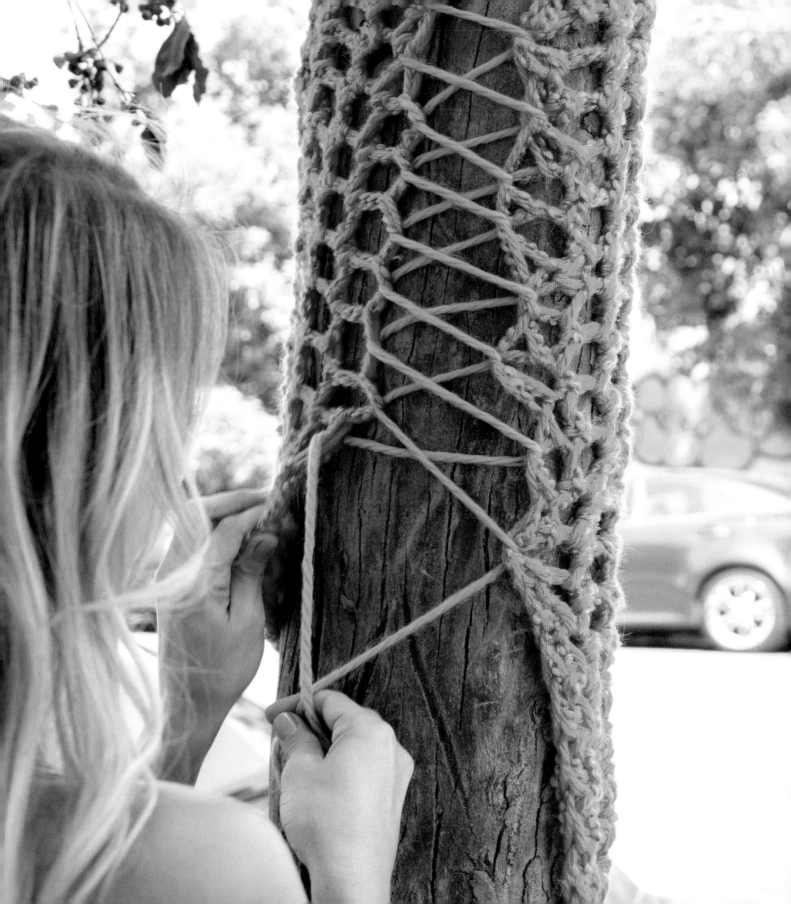

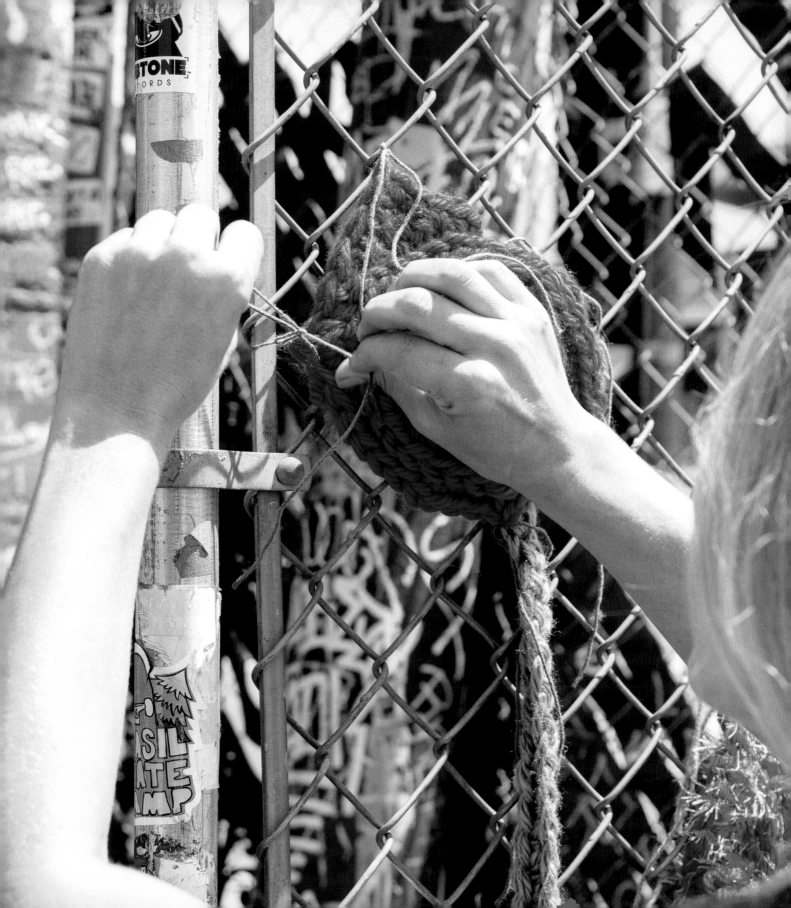

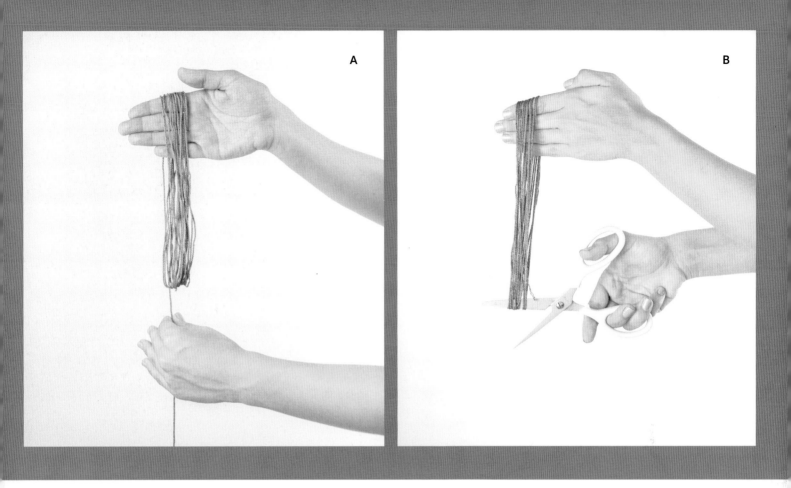

A

B

TIE IT

This technique is used for hanging nontraditional yarn bombs. It is the best way to attach your finished crochet piece to a chain-link fence or another grid-like surface, because you can add and remove ties easily without leaving a permanent mark. Cut strings of yarn about 6 inches (15 cm) long (**PHOTOS A and B**), and double knot them around the perimeter of your finished crochet piece, about every 6 inches (15 cm) apart and on all corners. Add more ties as needed. I recommend using a medium-weight yarn that has little to no stretch.

Place your crochet piece on the chain-link fence (or other surface) exactly where you want it, holding

it at the top in the middle. Take a moment to get a complete idea of how you are going to stretch and tie your crochet piece to the fence. When you are ready, begin double knotting your strings to attach the crochet to the fence. When you are done, cut the tails so the finished piece looks clean.

tip

If you are unsure if you are tying the string in the right place, tie a bow instead of a double knot until you are ready to fully commit to its positioning.

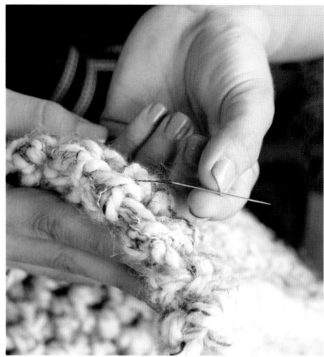

GLUE IT

Hot glue and spray adhesive work best with yarn. Hot glue adheres to yarn very quickly and is extremely resilient in all the elements Mother Nature sends our way. Spray adhesive works well for attaching a piece of crochet to a bag or a piece of fabric. It does not dry right away, so you can move and adjust the crochet piece until it is exactly right.

tip

Use hot glue to layer crochet elements on top of one another to build a more complex design from the ground up. This is my favorite technique, and it is the foundation of how I conceptualize every nontraditional yarn bomb I crochet. You can create endless combinations with this method, and every shape you add creates an even larger and more intricate picture.

SEW IT

With a sewing needle and thread, use a whip stitch to join crochet edges together. You can also attach crochet pieces to one another by sewing them into place with basic hand-sewing stitches. I like to sew crochet pieces that are made for fashion and for indoor use because it is invisible to the eye. Keep in mind that sewing takes additional time and is generally not as durable in the outdoor elements. When used properly, it can produce the cleanest and most beautiful results.

my top 10 tips for yarn bombing

1. Trust yourself. You have worked with the crochet piece for a long time. Let go of any doubts; you know the design inside and out.

2. Location, location, location. Location scout before you walk out the door. Make sure you know where you are putting it.

3. Ask permission. Do not install a yarn bomb on someone's property without getting permission from the owner. You will be surprised at how easy it is to get the green light.

4. Bring a step stool or wear platform shoes in case you have to reach up high during the installation.

5. Each piece is different, and no one knows what to do in the moment better than you.

6. Carry scissors, extra yarn, and a crochet hook just in case you need to make any quick fixes and so you can trim all visible loose ends.

7. Take a great photo. Snap a few test shots before you hang up your yarn bomb to make sure you are going to get the best final photo.

8. Once your yarn bomb is up, set it free. That is why the photo is so important!

9. Sign your work. Place a hashtag or a social media handle nearby so people can find you.

10. Share it with the world!

POSITIVE WORDS TO KEEP THE ARTISTIC PROCESS MOVING FORWARD WITH EASE:

- Stick to a deadline.
- You can, in fact, do it.
- Creative solutions arise when you work in constraints and have challenges.
- Ask for help.
- Stick to your color palette.

- There is beauty in the beginner.
- Keep moving forward even if it is not perfect.
- It's OK if you have to start over again.
- No one sees the imperfections like you do.
- Nothing is scary in the moment. Baby steps.

HOW TO CROCHET SHAPES

Some crochet projects may look daunting, but take a close look: even the most complex designs can be broken down into basic shapes. Use this section as a guide for creating various shapes. You can make different sizes depending on the yarn and the hook you choose. The larger your crochet hook, the larger the shape. To determine the right size, first consider what your final project will look like. If you are making something for a physical object, use a measuring tape and note the dimensions. For other projects, it can be helpful to sketch out the design. This can help you envision the shapes as smaller, more manageable pieces and help define the scale of your finished product.

materials

Yarn (bulky weight suggested for practice)
Hook (size P/11.5 mm suggested for practice)
Scissors

rectangle: length and width

The rectangle and the square are the most basic shapes and are most commonly used in traditional yarn bombing. You can easily stretch a crochet rectangle and wrap it around an object horizontally or vertically. Because crochet stretches, the rectangle is a very forgiving shape that allows you to make plenty of adjustments.

tip

I like to crochet the longer side of the rectangle first because I find it is easier to keep the sides straight. If you crochet the shorter side, you may need to add a chain before beginning each row of single crochet.

HOW TO CROCHET A RECTANGLE

1. Make a slip knot and ch until you reach your desired length.

2. Make 1 sc in the 2nd ch from the hook and 1 sc in each remaining stitch in the row.

3. Turn, make 1 sc in each of the remaining sc across.

4. Repeat step 3 until the rectangle reaches your desired width.

5. Finish off.

triangle: base and height

A triangle is crocheted using a technique known as decreasing. In single crochet, decreasing is one of the easiest ways to reduce the number of stitches in a row. To decrease, simply skip the first single crochet of the row, then continue working. A crochet triangle shape is useful when you are making a piece to fit an object with an unusual shape or creating an abstract yarn bomb for a chain-link fence.

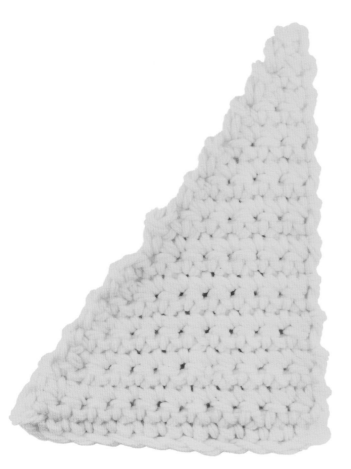

1. Make a slip knot and ch until you reach your desired base width.

2. Make 1 sc in the 2nd ch from the hook and 1 sc in each remaining stitch in the row.

3. Turn, skip the first sc, make 1 sc in each sc across.

4. Turn, make 1 sc in each sc across.

5. Repeat steps 3 and 4 until you reach your desired height. To make a triangle that comes to a point in the middle, repeat step 3 until you reach your desired height.

6. Finish off.

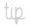
tip

If the height of your triangle measures much taller than your base, you will not have to skip the first single crochet of a row as frequently. If the height of your triangle measures much shorter than your base, you may have to skip the first 2 single crochets of a row.

circle: diameter

It takes time and practice to crochet a circle, but once you have mastered this shape, you can use it in unlimited ways. To make a circle you work in the round, which means you crochet in a circle. Adding more rounds is like adding more rows. To keep the circle growing evenly, use a technique called increasing. To increase, work two single crochet stitches in the same loop and continue working. With each round, you increase less; if you increase too much, the circle will not lie flat.

HOW TO CROCHET A CIRCLE

1. Make a slip knot and ch 3. (**PHOTO A**)

2. Make 2 sc in the 2nd ch from the hook and 4 sc in the next ch.

3. Keep working your way around in a circle and make 2 sc in the next stitch on the back of the ch. You will now begin working in the round. (**PHOTO B**)

Round 1

1. Make 2 sc in the next sc, then make 1 sc in the next sc.

2. Repeat step 1 around. (**PHOTO C**)

> ~ tip ~
>
> If you find yourself losing track of where a round starts and ends, place a stitch marker or safety pin.

Round 2

1. Make 2 sc in the next sc, make 1 sc in the next 2 sc.

2. Repeat step 1 around.

Round 3

1. Make 2 sc in the next sc, make 1 sc in the next 3 sc.

2. Repeat step 1 around.

Round 4

1. Make 2 sc in the next sc, make 1 sc in the next 4 sc.

2. Repeat step 1 around.

Round 5

1. Make 2 sc in the next sc, make 1 sc in the next 5 sc.

2. Repeat step 1 around.

3. Continue this pattern until the circle is the desired size. With every round, add one more sc before making 2 sc in the next sc.

4. Finish off. (**PHOTO D**)

> ~ tip ~
>
> If the edges of your circle start to curl inward, **increase** more often. If your circle begins to look wavy, stop increasing. Once the circle is flat again, return to the pattern.

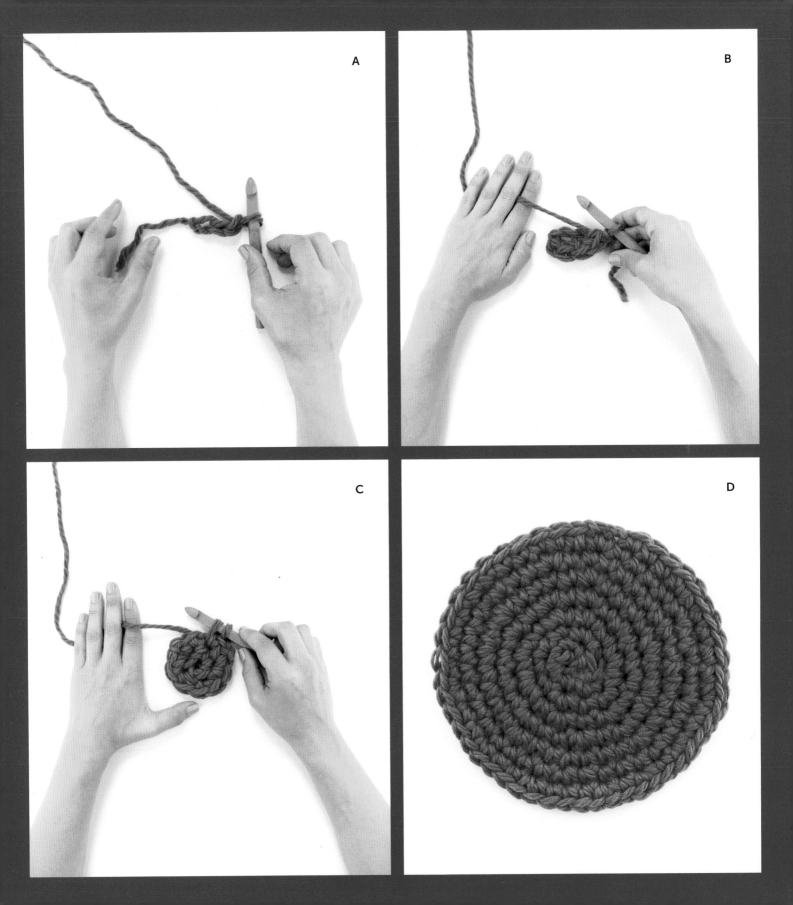

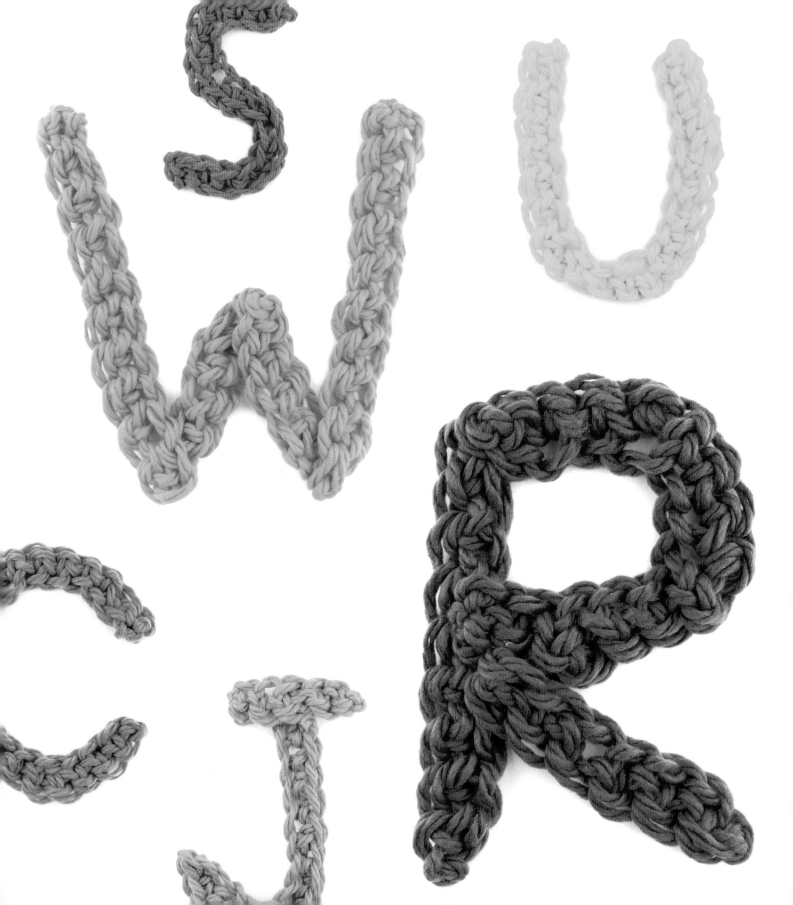

HOW TO CROCHET THE ALPHABET

Learning how to crochet the letters of the alphabet is a useful skill for any yarn bombing artist. Letters form words that allow you the freedom to express yourself. Crocheting letters is simple when you break them down into individual pieces. You can turn a rectangle into a curve by increasing or decreasing stitches accordingly. If you want to exercise your creative muscle, you can modify patterns by using a particular size hook or adjusting the number of stitches in each letter consistently. For example, a very small hook with thin yarn will make tiny text. Once you have crocheted your message, you can either keep each letter as an individual piece or attach them to a larger backdrop.

choose a variety of colors to have available while crocheting the alphabet

materials

Yarn (bulky weight suggested for practice)

Hook (size P/11.5 mm suggested for practice)

Scissors

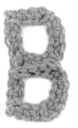

1. Make a slip knot and ch 11.

2. Make 1 sc in the 2nd ch from the hook, then make 1 sc in each of the next 10 ch.

3. Finish off.

4. Repeat steps 1–3 to make a second piece.

5. Make a slip knot and ch 5.

6. Make 1 sc in the 2nd ch from the hook, then make 1 sc in each of the next 4 ch.

7. Finish off.

8. Glue or sew together.

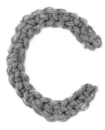

1. Make a slip knot and ch 10.

2. Make 1 sc in the 2nd ch from the hook, then make 1 sc in each of the next 9 ch.

3. Finish off.

4. Make a slip knot and ch 13.

5. Make 1 sc in the 2nd ch from the hook, then make 1 sc in each ch across, increasing in the 4th, 8th, and 12th ch—15 stitches.

6. Finish off.

7. Repeat steps 4–6 to make a second piece.

8. Glue or sew together.

1. Make a slip knot and ch 20.

2. Make 1 sc in the 2nd ch from the hook, then make 1 sc in each ch across, increasing in the 4th, 11th, and 18th ch—22 stitches.

3. Finish off.

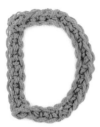

1. Make a slip knot and ch 10.

2. Make 1 sc in the 2nd ch from the hook, then make 1 sc in each of the next 9 ch.

3. Finish off.

4. Make a slip knot and ch 20.

5. Make 1 sc in the 2nd ch from the hook, then make 1 sc in each ch across, increasing in the 4th, 11th, and 18th ch—22 stitches.

6. Finish off.

7. Glue or sew together.

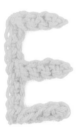

1. Make a slip knot and ch 10.

2. Make 1 sc in the 2nd ch from the hook, then make 1 sc in each of the next 9 ch.

3. Finish off.

4. Make a slip knot and ch 5.

5. Make 1 sc in the 2nd ch from the hook, then make 1 sc in each of the next 4 ch.

6. Finish off.

7. Repeat steps 4–6 to make three short pieces total.

8. Glue or sew together.

1. Make a slip knot and ch 10.

2. Make 1 sc in the 2nd ch from the hook, then make 1 sc in each of the next 9 ch.

3. Finish off.

4. Make a slip knot and ch 5.

5. Make 1 sc in the 2nd ch from the hook, then make 1 sc in each of the next 4 ch.

6. Finish off.

7. Repeat steps 4–6 to make a second short piece.

8. Glue or sew together.

1. Make a slip knot and ch 20.

2. Make 1 sc in the 2nd ch from the hook, then make 1 sc in each of the ch across, increasing in the 4th, 11th, and 18th ch—22 stitches.

3. Finish off.

4. Make a slip knot and ch 6.

5. Make 1 sc in the 2nd ch from the hook, then make 1 sc in each of the next 5 ch.

6. Finish off.

7. Glue or sew together.

1. Make a slip knot and ch 10.

2. Make 1 sc in the 2nd ch from the hook, then make 1 sc in each of the next 9 ch.

3. Finish off.

4. Repeat steps 1–3 to make a second piece.

5. Make a slip knot and ch 5.

6. Make 1 sc in the 2nd ch from the hook, then make 1 sc in each of the next 4 ch.

7. Finish off.

8. Glue or sew together.

1. Make a slip knot and ch 10.

2. Make 1 sc in the 2nd ch from the hook, then make 1 sc in each of the next 9 ch.

3. Finish off.

4. Make a slip knot and ch 6.

5. Make 1 sc in the 2nd ch from the hook, then make 1 sc in each of the next 5 ch.

6. Finish off.

7. Repeat steps 4–6 to make a second short piece.

8. Glue or sew together.

1. Make a slip knot and ch 15.

2. Make 1 sc in the 2nd ch from the hook, then make 1 sc in each ch across, increasing in the 10th and 13th ch—16 stitches.

3. Finish off.

4. Make a slip knot and ch 6.

5. Make 1 sc in the 2nd ch from the hook, then make 1 sc in each of the next 5 ch.

6. Finish off.

7. Glue or sew together.

1. Make a slip knot and ch 10.

2. Make 1 sc in the 2nd ch from the hook, then make 1 sc in each of the next 9 ch.

3. Finish off.

4. Make a slip knot and ch 7.

5. Make 1 sc in the 2nd ch from the hook, then make 1 sc in each of the next 6 ch.

6. Finish off.

7. Repeat steps 4–6 to make a second short piece.

8. Glue or sew together.

1. Make a slip knot and ch 10.

2. Make 1 sc in the 2nd ch from the hook, then make 1 sc in each of the next 9 ch.

3. Finish off.

4. Make a slip knot and ch 6.

5. Make 1 sc in the 2nd ch from the hook, then make 1 sc in each of the next 5 ch.

6. Finish off.

7. Glue or sew together.

1. Make a slip knot and ch 11.

2. Make 1 sc in the 2nd ch from the hook, then make 1 sc in each of the next 10 ch.

3. Finish off.

4. Repeat steps 1–3 to make a second piece.

5. Make a slip knot and ch 6.

6. Make 1 sc in the 2nd ch from the hook, then make 1 sc in each of the next 5 ch.

7. Finish off.

8. Repeat steps 5–7 to make a second short piece.

9. Glue or sew together.

4. Repeat steps 1–3 to make a second piece.

5. Make a slip knot and ch 11.

6. Make 1 sc in the 2nd ch from the hook, then make 1 sc in each of the next 10 ch.

7. Finish off.

8. Glue or sew together.

1. Make a slip knot and ch 24.

2. Join ends with 1 sc to work in the round. Make 1 sc in each ch around, increasing in the 4th, 10th, 16th, and 23rd ch—27 stitches.

3. Finish off.

1. Make a slip knot and ch 10.

2. Make 1 sc in the 2nd ch from the hook, then make 1 sc in each of the next 9 ch.

3. Finish off.

1. Make a slip knot and ch 10.

2. Make 1 sc in the 2nd ch from the hook, then make 1 sc in each of the next 9 ch.

3. Finish off.

4. Make a slip knot and ch 13.

5. Make 1 sc in the 2nd ch from the hook, then make 1 sc in each ch across, increasing in the 4th, 8th, and 12th ch—15 stitches.

6. Finish off.

7. Glue or sew together.

1. Make a slip knot and ch 24.

2. Join ends with 1 sc to work in the round. Make 1 sc in each ch around, increasing in the 4th, 10th, 16th, and 23rd ch—27 stitches.

3. Finish off.

4. Make a slip knot and ch 6.

5. Make 1 sc in the 2nd ch from the hook, then make 1 sc in each of the next 5 ch.

6. Finish off.

7. Glue or sew together.

1. Make a slip knot and ch 10.

2. Make 1 sc in the 2nd ch from the hook, then make 1 sc in each of the next 9 ch.

3. Finish off.

4. Make a slip knot and ch 13.

5. Make 1 sc in the 2nd ch from the hook, then make 1 sc in each ch across, increasing in the 4th, 8th, and 12th ch—15 stitches.

6. Finish off.

7. Make a slip knot and ch 7.

8. Make 1 sc in the 2nd ch from the hook, then make 1 sc in each of the next 6 ch.

9. Finish off.

10. Glue or sew together.

tip

Once you have glued or sewn your letters together, lay them out on a flat surface to stretch and manipulate the crochet so it looks just right. Crochet is very forgiving, and even a small adjustment can make mistakes disappear.

1. Make a slip knot and ch 18.

2. Make 1 sc in the 2nd ch from the hook, then make 1 sc in each ch across, increasing in the 4th and 7th ch and decreasing in the 13th and 15th ch.

3. Finish off.

1. Make a slip knot and ch 20.

2. Make 1 sc in the 2nd ch from the hook, then make 1 sc in each ch across, increasing in the 4th, 11th, and 18th ch—22 stitches.

3. Finish off.

1. Make a slip knot and ch 10.

2. Make 1 sc in the 2nd ch from the hook, then make 1 sc in each of the next 9 ch.

3. Finish off.

4. Make a slip knot and ch 7.

5. Make 1 sc in the 2nd ch from the hook, then make 1 sc in each of the next 6 ch.

6. Finish off.

7. Glue or sew together.

1. Make a slip knot and ch 11.

2. Make 1 sc in the 2nd ch from the hook, then make 1 sc in each of the next 10 ch.

3. Finish off.

4. Repeat steps 1–3 to make a second piece.

5. Glue or sew together.

1. Make a slip knot and ch 11.

2. Make 1 sc in the 2nd ch from the hook, then make 1 sc in each of the next 10 ch.

3. Finish off.

4. Repeat steps 1–3 to make a second piece.

5. Make a slip knot and ch 6.

6. Make 1 sc in the 2nd ch from the hook, then make 1 sc in each of the next 5 ch.

7. Finish off.

8. Repeat steps 5–7 to make a second short piece.

9. Glue or sew together.

1. Make a slip knot and ch 11.

2. Make 1 sc in the 2nd ch from the hook, then make 1 sc in each of the next 10 ch.

3. Finish off.

4. Repeat steps 1–3 to make a second piece.

5. Glue or sew together.

1. Make a slip knot and ch 6.

2. Make 1 sc in the 2nd ch from the hook, then make 1 sc in each of the next 5 ch.

3. Finish off.

4. Repeat steps 1–3 to make a second piece.

5. Make a slip knot and ch 7.

6. Make 1 sc in the 2nd ch from the hook, then make 1 sc in each of the next 6 ch.

7. Finish off.

8. Glue or sew together.

1. Make a slip knot and ch 11.

2. Make 1 sc in the 2nd ch from the hook, then make 1 sc in each of the next 10 ch.

3. Finish off.

4. Make a slip knot and ch 7.

5. Make 1 sc in the 2nd ch from the hook, then make 1 sc in each of the next 6 ch.

6. Finish off.

7. Repeat steps 4–6 to make a second short piece.

8. Glue or sew together.

> ~ *tip!* ~
>
> Finish off your ends by tying a double knot.
> Every piece of the letters is made of just
> a foundation chain and one row of single
> crochet, so your extra starting yarn and
> ending yarn hang side by side once you
> are finished crocheting. Cut all loose ends
> before gluing and sewing the pieces of
> your letters together.

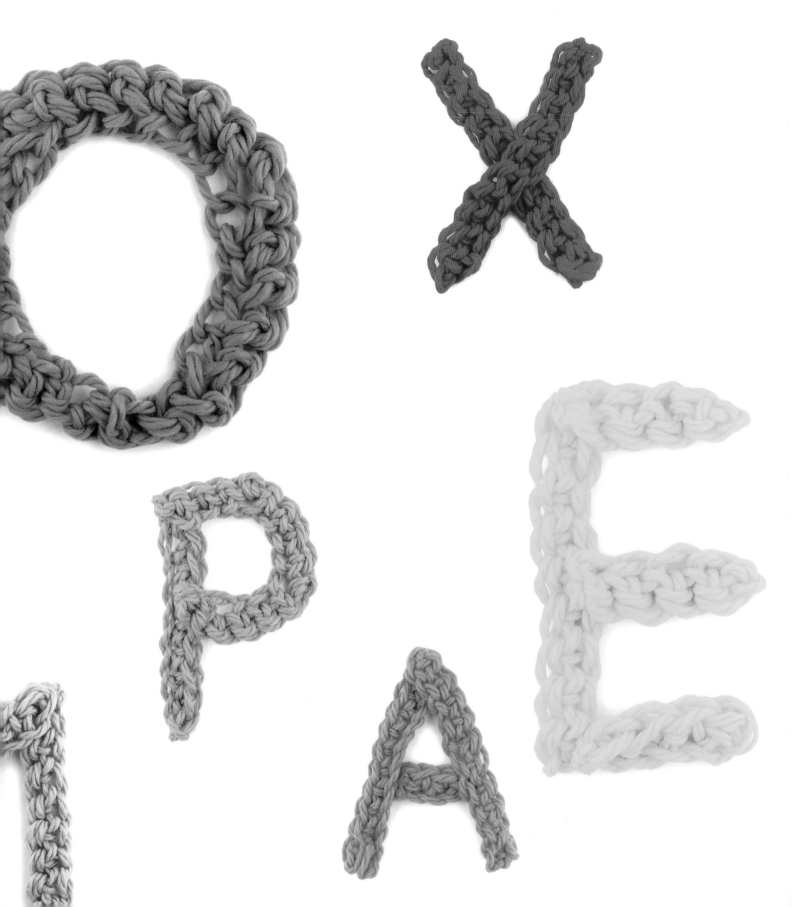

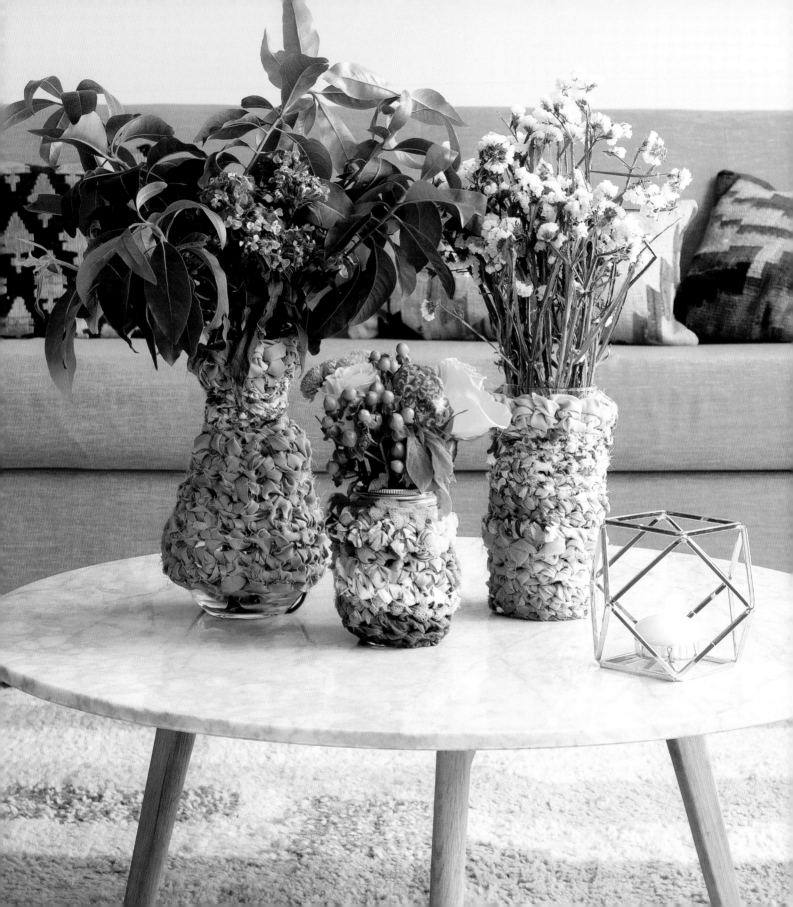

INDOOR PROJECTS

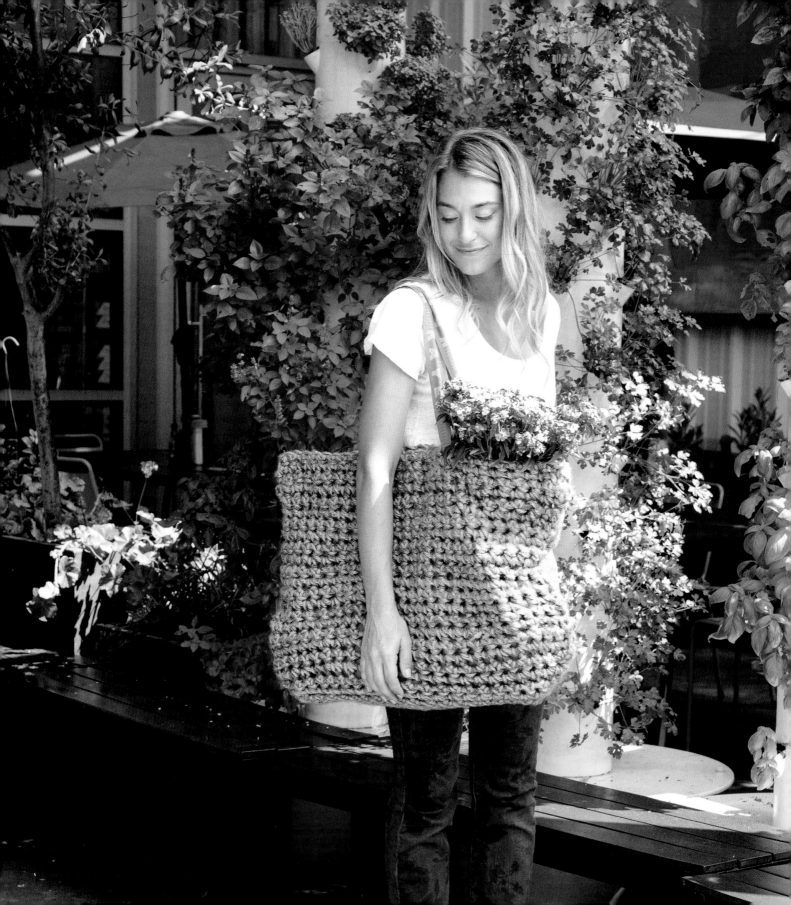

reusable shopping bag

I am constantly carrying yarn and other odds and ends around town, so it was only a matter of time until I yarn bombed my reusable shopping bag. This is a fun way to transform an ordinary bag into a work of art. I used a durable bag as a base so that I could carry even the heaviest haul without worrying. I've done this project a few times now in different shades of the same color, changing my working yarn when inspiration strikes. Sometimes I like to crochet with the radio on and change color every time a new song starts to play.

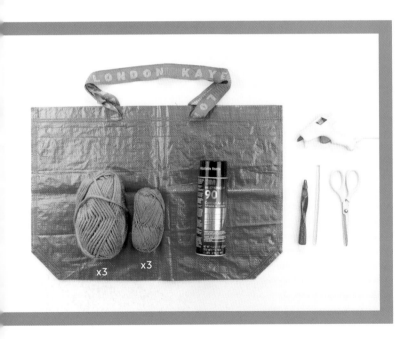

x3 x3

materials

YARN: 3 bulky and 3 medium skeins in different shades of green, double stranded

Size US S/35 (20 mm) hook

Measuring tape

Scissors

Durable reusable shopping bag

3M Hi-Strength 90 Spray Adhesive

Sewing needle and thread

Hot glue gun (optional)

tip

Keep your shopping bag nearby so you can measure your crochet on top of it as you work. This is a great way to make sure the piece is the right size and the edges are straight.

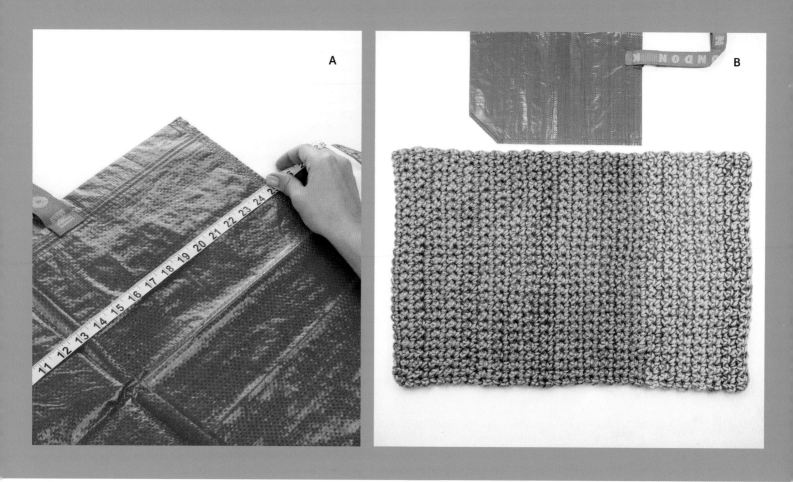

here's how to make it

1. Determine the length of your crochet piece by measuring one side of the bag from the top edge (directly below the strap) to the bottom. Double this measurement. For example, if one side of the bag measures 20 inches (51 cm), your total length will be 40 inches (101.5 cm). If your bag has a flat bottom, measure the short end and add to the length. For example, if the bottom is 4 inches (10 cm) wide, your total length will be 44 inches (112 cm). Determine the width of your crochet piece by measuring from the left edge of the bag to the right. (**PHOTO A**) If your bag has flat sides, add one side's short end to the width.

2. Make a slip knot with both strands of green yarn and ch until your piece is the correct width.

3. Make 1 sc in the 2nd ch from the hook and 1 sc in each remaining stitch in the row.

4. Turn, make 1 sc in each remaining sc across.

5. Repeat step 4 until your rectangle is the correct length. (**PHOTO B**)

6. Finish off.

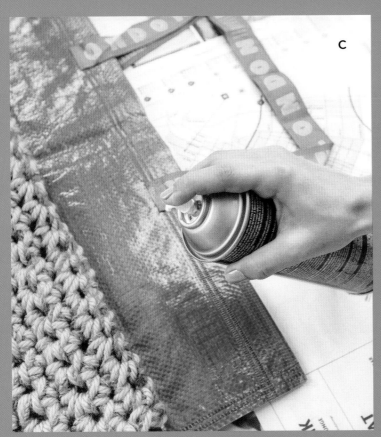

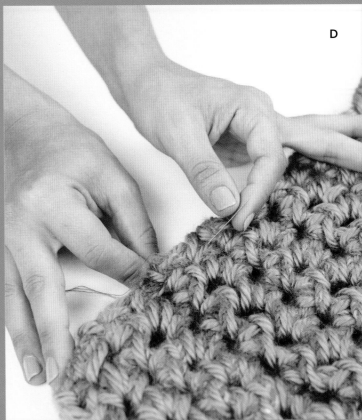

here's how to yarn bomb it

1. From about 6 inches (15 cm) away, spray one side of the bag with a light coat of adhesive spray. (**PHOTO C**) Make sure it is not too wet; if it is, use a paper towel to blot. Center the crochet piece on one side of the bag, taking care to align the edges of the crochet and the bag. Be sure the crochet lies flat. Press gently, and let dry for five minutes.

2. If your bag has a bottom panel, spray it and wrap the crochet. Flip the bag, spray the other side, and continue wrapping. Let dry for five minutes.

3. Sew the side edges of the crochet together. Make it tight so the crochet does not sag. (**PHOTO D**)

4. Optional: For extra strength, sew or hot glue the crochet around the top edges of the bag so it stays in place.

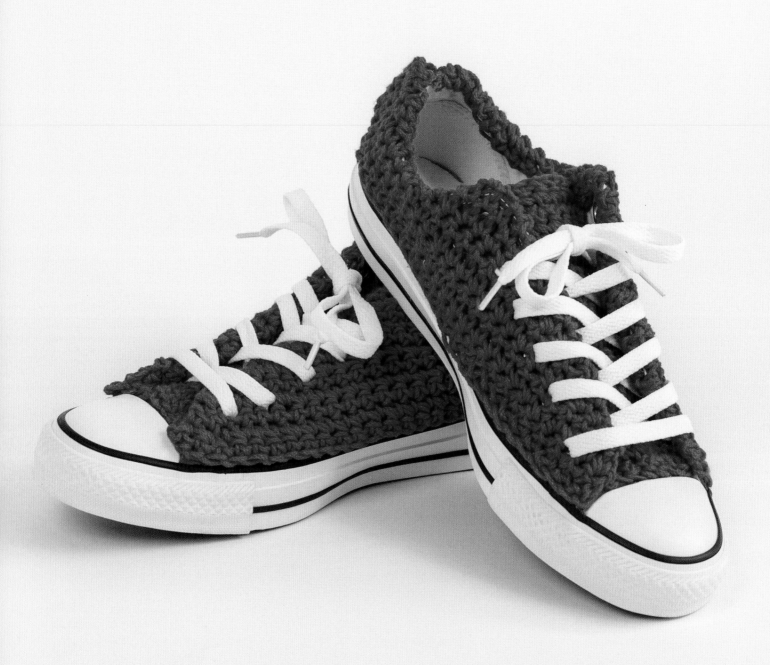

sneakers

Every time I walk out the door rocking my crochet sneakers, I make a fashion statement. They are my favorite crochet fashion accessory; they are so unique that heads cannot help but turn. I have yarn bombed countless pairs of sneakers because they're so fun to make and wear, but I still have to dedicate time and attention to every single stitch. Counting is a big part of making the crochet pieces necessary to yarn bomb a sneaker, so make sure you are in the zone when you take on this project.

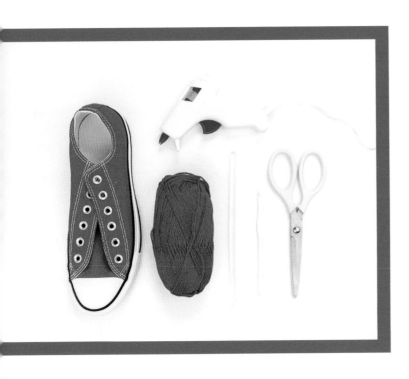

materials

YARN: 1 lightweight skein in any color

Size US J/10 (6 mm) hook

Scissors

Low-top sneakers, women's size 7. For other shoe sizes, refer to the modification guide on page 61.

Hot glue gun

tip

Crochet this project with the shoe in your lap and adjust your number of stitches as needed. Every size shoe is a little different, so don't hesitate to switch up the stitch count.

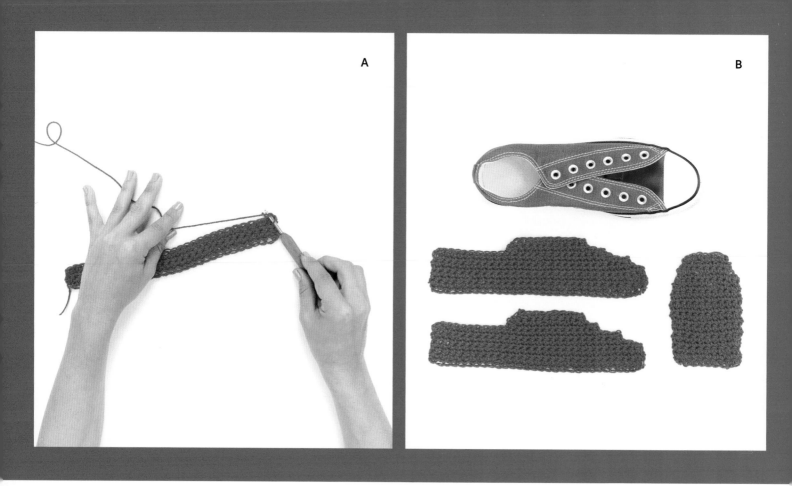

here's how to make it

THE SIDES

1. Make a slip knot with the yarn and ch 28.

2. Make 1 sc in the 2nd ch from the hook and 1 sc in each remaining ch in the row—27 ch.

3. Turn, make 1 sc in each remaining sc across—27 sc.

4. Repeat step 3 one time. (**PHOTO A**)

5. Turn, skip first sc, make 1 sc in each sc across. You are decreasing the number of stitches in the row by 1—26 sc.

6. Turn, sc in each remaining sc across—26 sc.

7. Turn, skip first sc, make 1 sc in each sc across—25 sc.

8. Turn, make 1 sc in each remaining sc across—25 sc.

9. Turn, skip first sc, make 1 sc in each of the next 14 sc across—14 sc. Stop before the end of the previous row because the shape of the crochet sneaker curves inward.

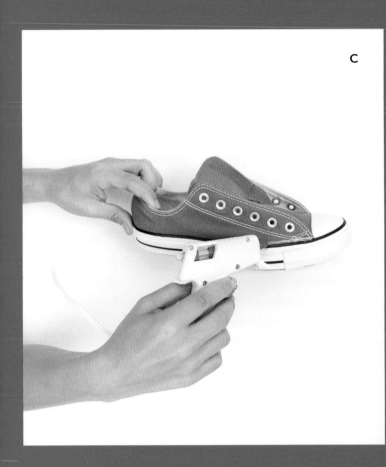

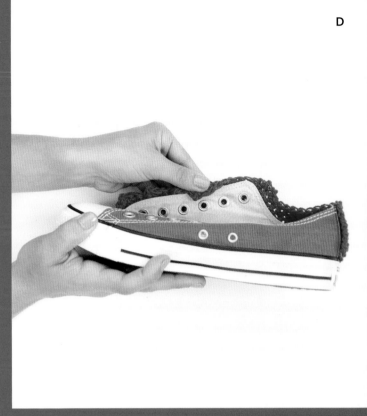

10. Turn, skip first sc, make 1 sc in each of the next 11 sc across—11 sc.

11. Turn, skip first sc, make 1 sc in each of the next 10 sc across—10 sc.

12. Finish off.

13. Repeat steps 1–12 to create three more sides. (**PHOTO B**)

Size Modification Guide

If you are working with a different size shoe, you will need to add or remove stitches from steps 1 and 4 and adjust the stitch count accordingly.

Step 1
Size 6: Ch 27.
Size 8: Ch 29.
Size 9: Ch 30.

Step 4
Size 6: Skip step 4.
Size 8: Repeat step 3 two times.
Size 9: Repeat step 3 three times.

THE TONGUE

1. Make a slip knot with the yarn and ch 11.

2. Make 1 sc in the 2nd ch from the hook and 1 sc in each of the remaining 10 ch.

3. Turn, make 1 sc in each remaining sc across—10 sc.

4. Repeat step 3 nineteen times.

5. Turn, skip the first sc, make 1 sc in each sc across. You are decreasing the number of stitches in the row by 1—9 sc.

6. Turn, skip the first sc, make 1 sc in each sc across. You are decreasing the number of stitches in the row by 1—8 sc.

7. Turn, make 1 sc in each sc across—8 sc.

8. Finish off.

9. Repeat steps 1–8 to create one more tongue.

here's how to yarn bomb it

1. Use hot glue to attach the finished crochet pieces to the shoes. Start by gluing the sides, working your way from the front to the back. (**PHOTO C**, page 61) Stretch the crochet pieces as needed so they lie flat against the sneaker. Fold any extra rows of crochet over the top of the sneaker and glue to the inside lining. Glue the tongue, starting at the top and working your way to the base. (**PHOTO D**, page 61)

2. Lace up sneakers and finish off with a bow.

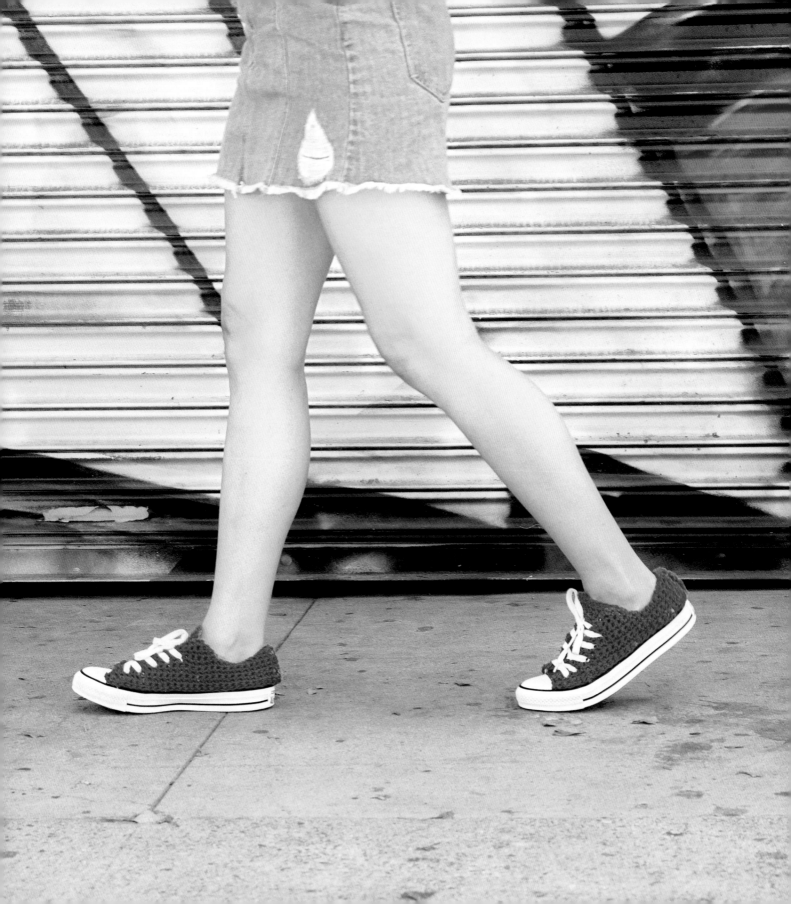

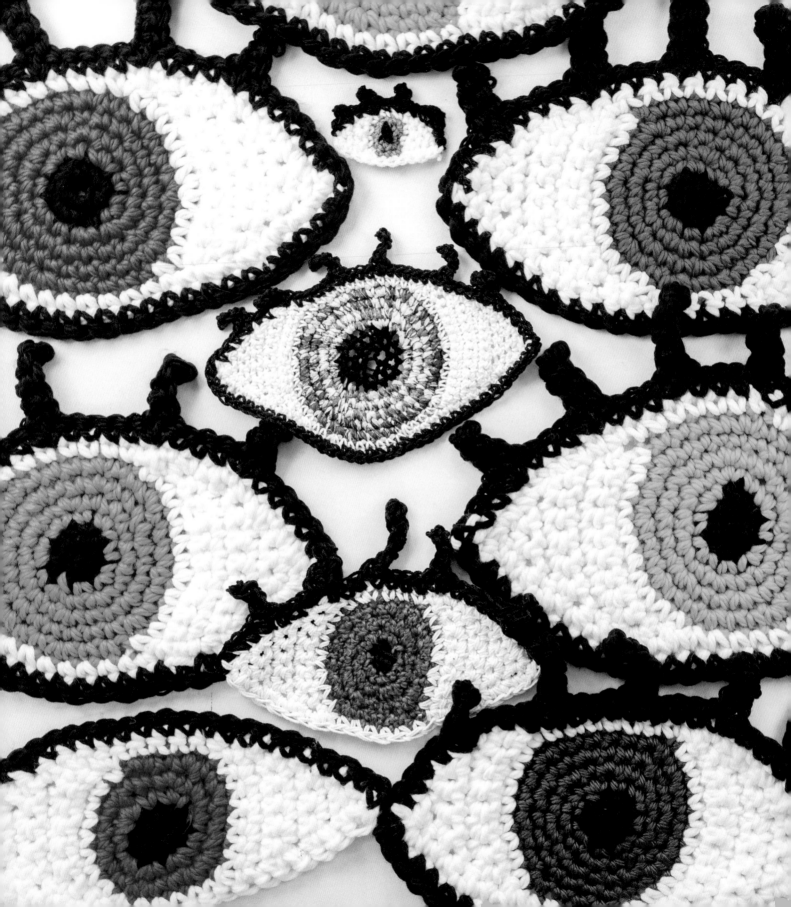

eye

The eye is a very powerful symbol. It has many meanings, some of which date back to 3200 BCE. I have found my own special meaning in the eye because it reminds me of my ancestors and all my loved ones. I frequently crochet eyeballs to use in my street art and as appliqués on sneakers, bags, and other accessories. Change out the colors called for in the pattern to create an eye that is personal to you.

materials

YARN: 1 bulky skein in black (pupil and eyelashes); 1 bulky skein in blue (cornea), or color of your choice; 1 bulky skein in white (sclera)

Size US P/15 (11.5 mm) hook

Sewing needle and thread (optional)

here's how to make it

1. Make a slip knot with black yarn and ch 3.

2. Make 2 sc in the 2nd ch from the hook and 4 sc in the next ch.

3. Keep working your way in a circle and make 2 sc in the next stitch on the back of your ch. This is the same pattern you use to make a circle (see page 38).

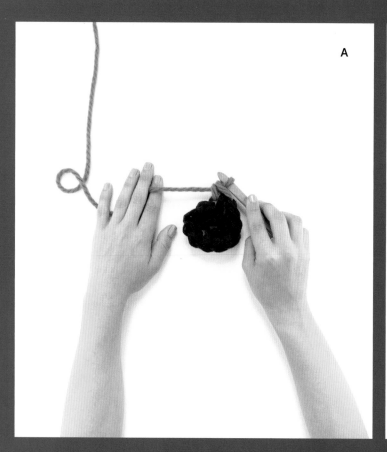

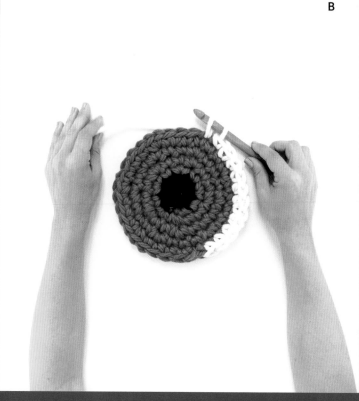

Change working yarn to blue. (PHOTO A)

Round 1

1. Make 2 sc in the next sc, make 1 sc in the next sc.

2. Repeat step 1 around.

Round 2

1. Make 2 sc in the next sc, make 1 sc in the next 2 sc.

2. Repeat step 1 around.

Round 3

1. Make 2 sc in the next sc, make 1 sc in the next 3 sc.

2. Repeat step 1 around.

Round 4

1. Make 2 sc in the next sc, make 1 sc in the next 4 sc.

2. Repeat step 1 around.

Change working yarn to white.

1. Continuing to sc around the edge of the circle, make 1 sc in the next 12 sc—12 sc. (**PHOTO B**)

2. Turn, skip the first sc, make 1 sc in each of the next 11 sc—11 sc. You will continue to decrease stitches in each row until you reach a point.

3. Turn, skip the first sc, make 1 sc in each of the next 9 sc—9 sc.

4. Turn, skip the first sc, make 1 sc in each of the next 8 sc—8 sc.

5. Turn, skip the first sc, make 1 sc in each of the next 6 sc—6 sc.

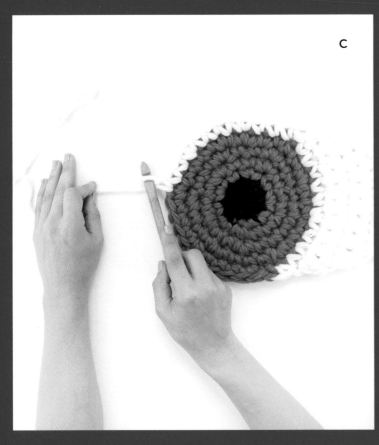

C

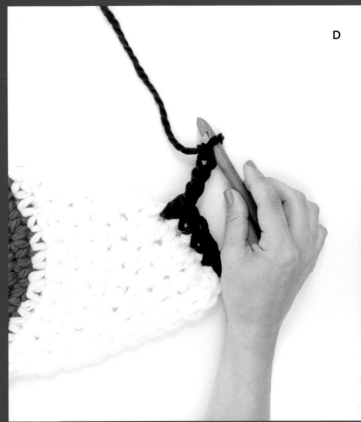

D

6. Turn, skip the first sc, make 1 sc in each of the next 4 sc—4 sc.

7. Turn, skip the first sc, make 1 sc in each of the next 2 sc—2 sc.

8. Turn, skip the first sc, make 1 sc in each of the next 1 sc—1 sc.

9. Turn, working your way around the outer edge of the shape, make 1 sc in each of the next 26 sc—26 sc. (**PHOTO C**)

10. Repeat steps 3–8.

11. Turn, working your way around the outer edge of the shape, make 1 sc in each of the next 27 sc—27 sc.

Change working yarn to black.

1. Continuing to work your way around the outer edge of the shape, make 1 sc in each of the next 4 sc.

2. Ch 4. (This ch is the foundation of your first eyelash.) (**PHOTO D**)

3. Turn, make 1 sc in the 2nd ch from the hook, make 1 sc in each of the next 3 ch, then make 1 sc in the same sc stitch you originally left off.

4. Continuing to work your way around the outer edge of the shape, make 1 sc in each of the next 4 sc.

5. Ch 5. (This ch is the foundation of your next eyelash.)

6. Turn, make 1 sc in the 2nd ch from the hook, make 1 sc in each of the next 4 ch, then make 1 sc in the same sc stitch you originally left off.

7. Continuing to work your way around the outer edge of the shape, make 1 sc in each of the next 4 sc.

8. Ch 6. (This ch is the foundation of your next eyelash.)

9. Turn, make 1 sc in the 2nd ch from the hook, make 1 sc in each of the next 5 ch, then make 1 sc in the same sc stitch you originally left off.

10. Continuing to work your way around the outer edge of the shape, make 1 sc in each of the next 4 sc.

11. Ch 5. (This ch is the foundation of your next eyelash.)

12. Turn, make 1 sc in the 2nd ch from the hook, make 1 sc in each of the next 4 ch, then make 1 sc in the same sc stitch you originally left off.

13. Ch 4. (This ch is the foundation of your next eyelash.)

14. Turn, make 1 sc in the 2nd ch from the hook, make 1 sc in each of the next 3 ch, then make 1 sc in the same sc stitch you originally left off.

15. Continuing to work your way around the outer edge of the eyeball, make 1 sc in each of the next 4 sc or until you reach the point of your eyeball.

16. Continuing to work your way around the outer edge of your eyeball, make 1 sc in each of the next 28 sc—28 sc.

17. Finish off.

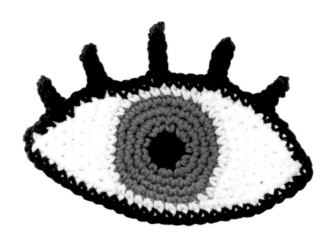

tip

To make smaller eyeballs, use a smaller hook and a lighter-weight yarn. You may need to modify the total number of rounds to keep your eyeball proportionate.

here's how to yarn bomb it

Sew it to a bag or jacket and use it as an appliqué.

Tie it up on a chain-link fence (see page 31).

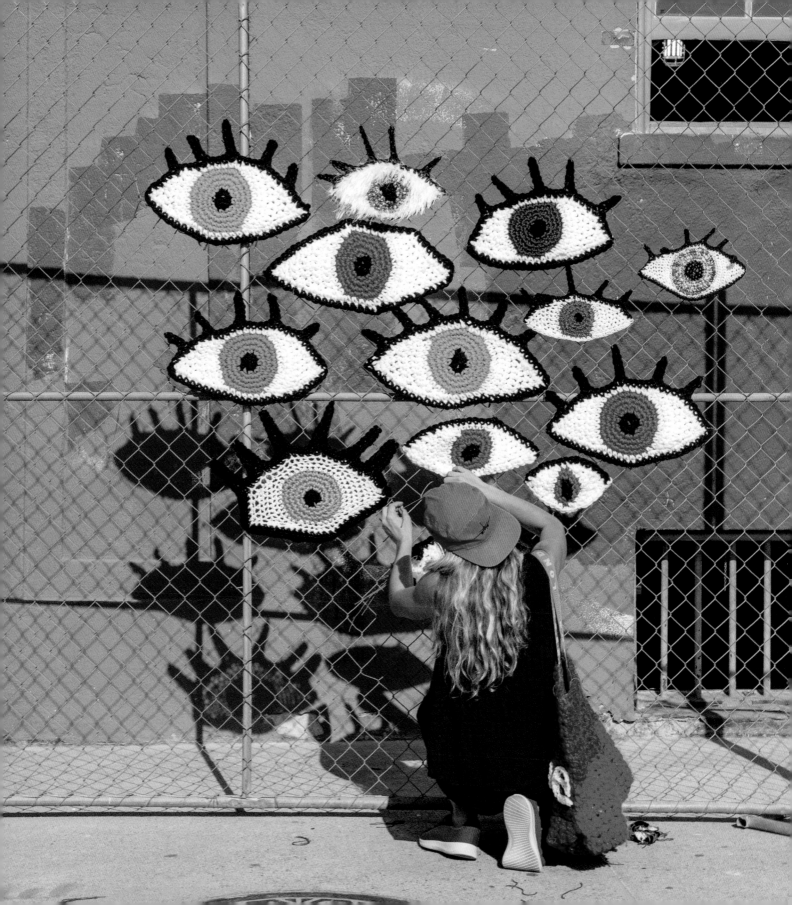

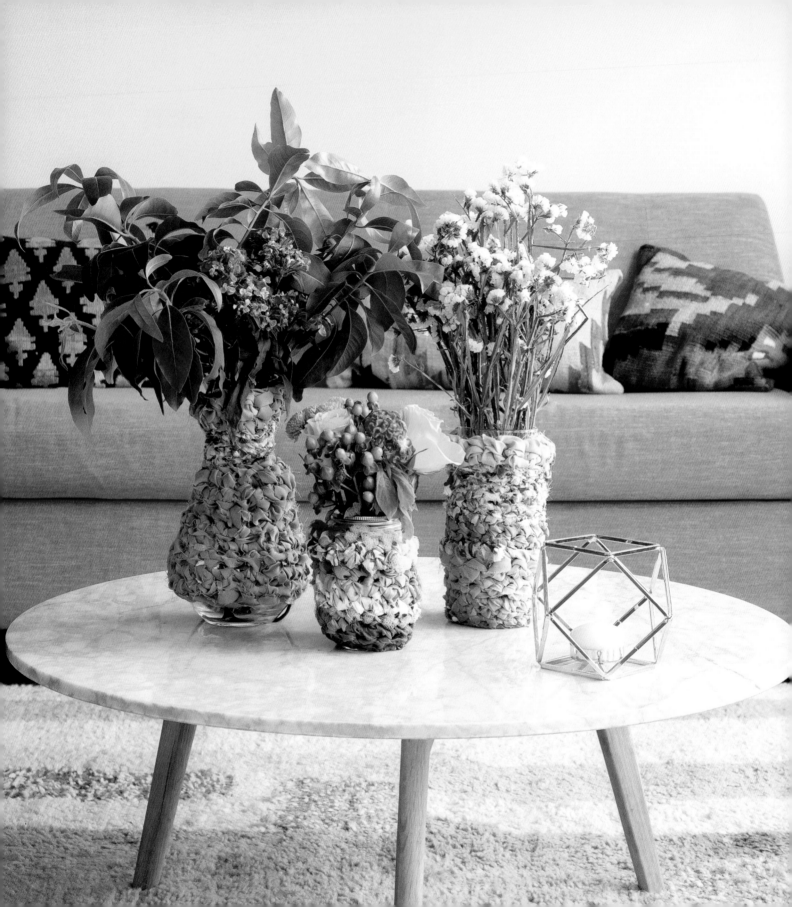

vase cozy

I have always enjoyed crocheting with unconventional materials. Fabric is one of the best materials to work with because you crochet the same way as with yarn. You can make your own yarn out of recycled fabric by cutting it into long strips. This is a perfect project to give as a gift. To make it even more special, arrange a flower bouquet that complements the color palette of the vase cozy.

size

10 inches (25 cm) by 7 inches (18 cm)

materials

YARN: About 20 multicolored fabric strips, approximately 60 inches (152 cm) by 2 inches (5 cm)

Size US P/15 (11.5 mm) hook

Scissors

Vase: Mason jar or larger

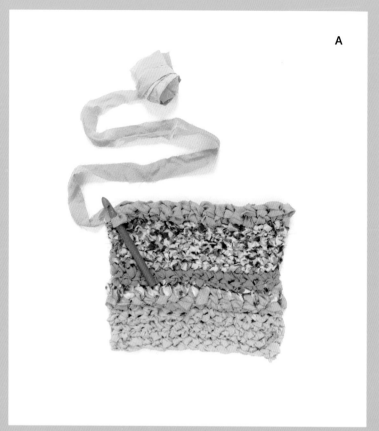

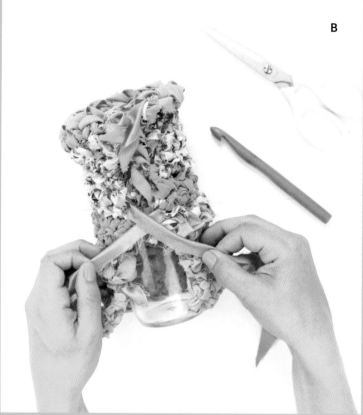

here's how to make it

1. Make a slip knot and ch until the length reaches 10 inches (25 cm).

2. Make 1 sc in the 2nd ch from the hook and 1 sc in each remaining ch.

3. Turn, make 1 sc in each remaining sc across. For this step, change the fabric strip you are working with as desired. Cut the old color and join together the new color with a double knot.

4. Repeat step 3 until the width reaches 7 inches (18 cm). (**PHOTO A**)

5. Finish off. Cut or hide any loose ends where you changed the fabric strip.

here's how to yarn bomb it

Wrap the finished crochet piece around the vase and weave strings through the crochet loops. (**PHOTO B**; see page 28) Adjust the placement until it looks just right.

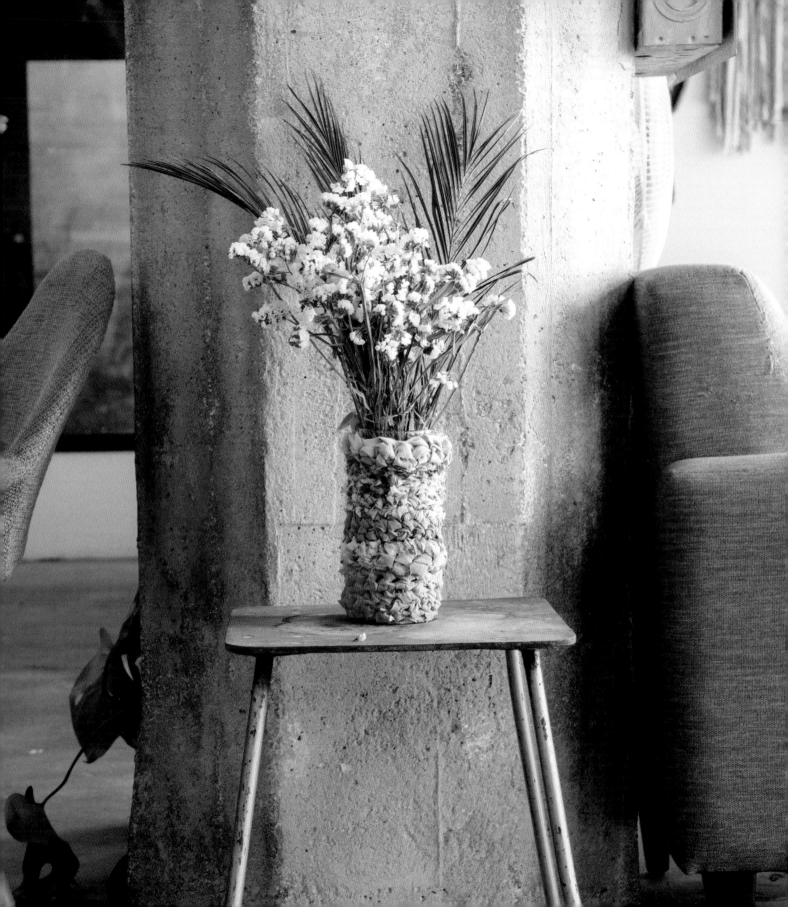

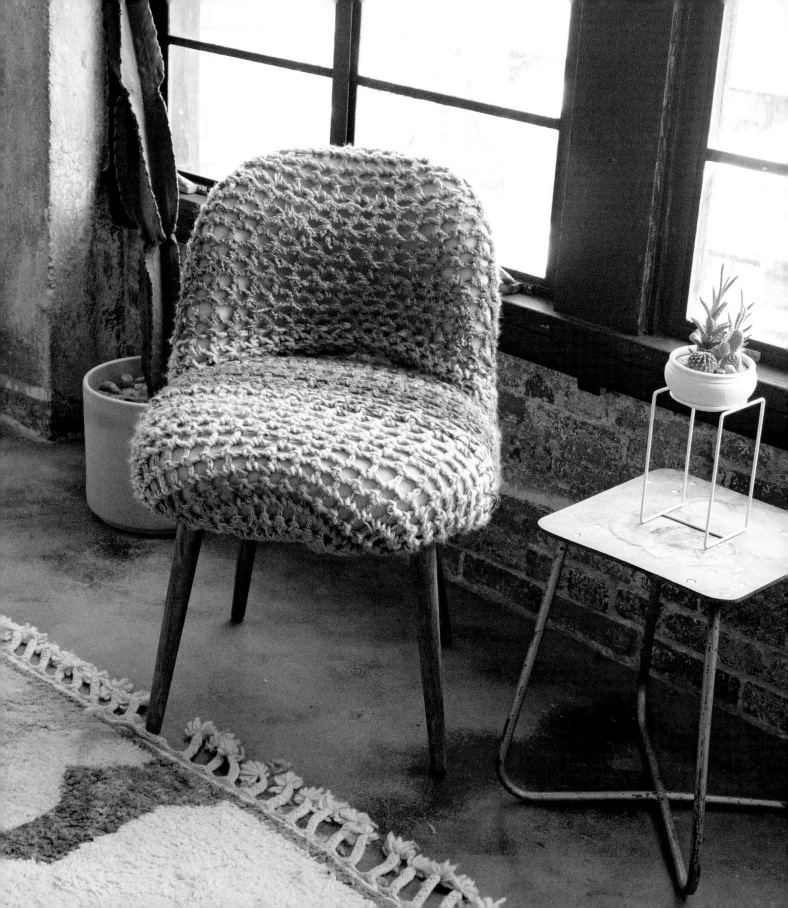

chair

hen I started decorating my apartment, I wanted to add a couple of crochet pieces to make the living room feel warmer. Yarn bombing a chair was one way of doing that. I decided to keep the color palette neutral, so it did not stand out too much. An unexpected plus to yarn bombing a chair is that the crochet piece not only makes the chair more beautiful, but also makes it a lot more comfortable.

materials

YARN: About 6 skeins of yarn in a variety of bulky, medium, and light weights (I like to double strand a bulky yarn and a sparkly lightweight yarn for this project)

Size US S/35 (20 mm) hook

Measuring tape

Armless chair

Scissors

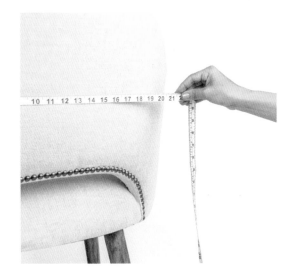

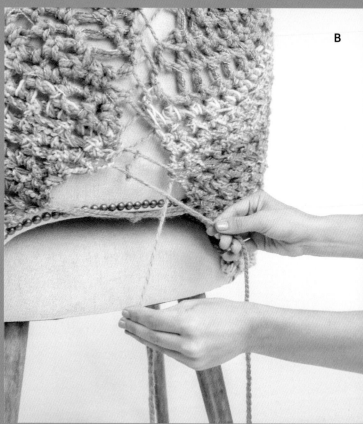

here's how to make it

1. Measure the chair. Most chairs can be yarn bombed with two rectangles: one for the top cushion and one for the bottom cushion. The cushions will likely be different sizes. (**PHOTO ON PAGE 75**)

2. Make a slip knot and ch until you reach your desired length for the top cushion.

3. Make 1 sc in the 2nd ch from the hook and 1 sc in each remaining ch.

4. Turn, make 1 sc in each remaining sc across.

5. Repeat step 4 and change your working color yarns every now and then (see page 19) until the

rectangle reaches your desired width. Check your crochet piece against the chair as you work. Remember that crochet stretches, so adjust the number of stitches accordingly. (**PHOTO A**)

6. Finish off.

7. Repeat steps 2–6 to make a second piece.

 tip

Focus on making a shape that is the same as the exposed part of the cushion even if you are cutting, stopping, and starting rows in uneven places. Use the cushion as a guide.

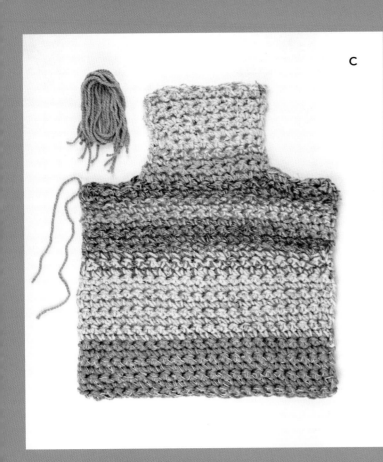

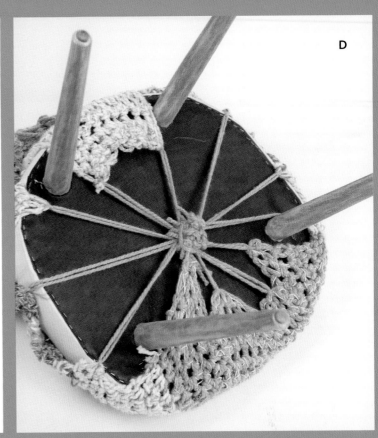

here's how to yarn bomb it

1. To attach the crochet to the top cushion, use the "Weave it" technique (see page 28). If your piece is not large enough, add additional rows of sc until it is the perfect size. (**PHOTO B**)

2. To attach the crochet to the bottom cushion, use a variation of the "Tie it" technique (see page 31). Double knot long strings around the perimeter of the finished crocheted piece. (**PHOTO C**) Wrap the crochet around the cushion. Tie the strings in a large knot, and knot extra strings to make sure the entire cushion is covered. You will not see the bottom part of the chair when it is right side up, so tie your strings any way you'd like. (**PHOTO D**)

3. Finish off.

OUTDOOR PROJECTS

bike rack cozy

When I walk around New York City, I tend to get overwhelmed by the amount of concrete and dark colors around me. Bike racks are spread all over the city, and they are the perfect object to yarn bomb—you can add a little color to the urban environment without leaving a permanent mark. After I put up a yarn bomb on a city street, I like to step back and watch the reactions of the passersby. It is always exciting to see someone smile because of something you created.

In this project, practice changing color at the ends of rows (see page 19). You can alternate between two colors to make simple stripes, or you can switch among a variety of colors to make color blocks.

materials

YARN: 4 bulky skeins in a variety of colors

Size US S/35 (20 mm) hook

Scissors

tip

Play around with the number of rows you make out of one color. Counting is helpful if your goal is to have a symmetrical finished piece of crochet.

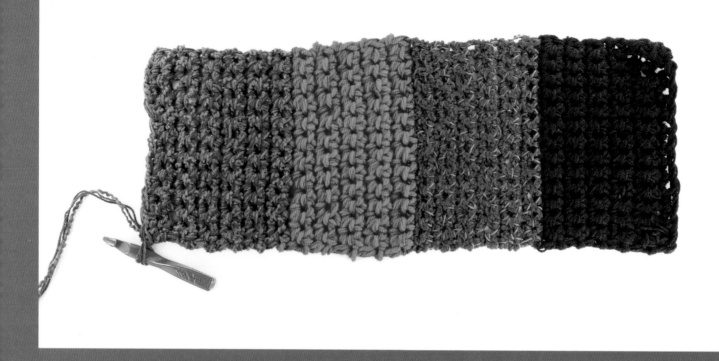

here's how to make it

1. Make a slip knot and ch until you reach a width of 6 inches (15 cm).

2. Make 1 sc in the 2nd ch from the hook and 1 sc in each remaining ch.

3. Turn, make 1 sc in each remaining sc across.

4. Repeat step 3 until your rectangle reaches 72 inches (183 cm). Change the color of your working yarn as desired (see page 19). (**PHOTO A**)

5. Finish off. (**PHOTO B**)

tip

Be careful: In this pattern you work across in short rows. As the crochet piece gets longer, it takes practice to keep the edges perfectly symmetrical. Luckily, all the mistakes disappear when you yarn bomb the finished crochet piece.

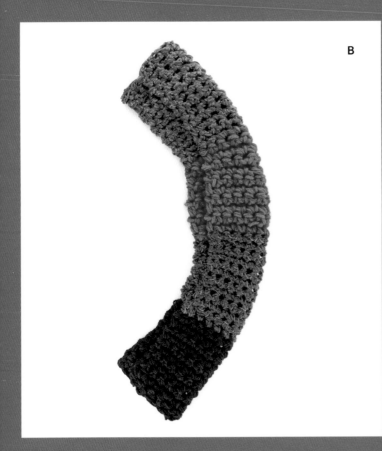

B

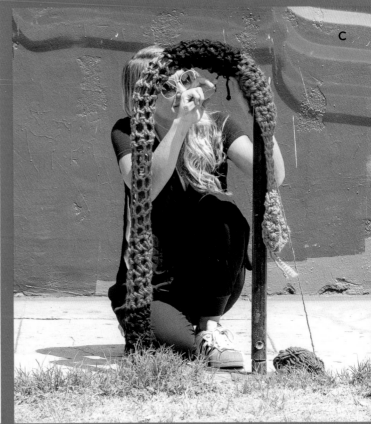

C

here's how to yarn bomb it

Wrap the finished piece of crochet around the bike rack from back to front, and weave strings through the loops from one side to the other. (**PHOTO C**; see page 28) Cut all loose ends.

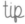

~~~~~~ tip ~~~~~~

To make the crochet fit perfectly, wrap a piece of yarn around your finished crocheted piece at the base of the bike rack. Do the same thing on the other side.

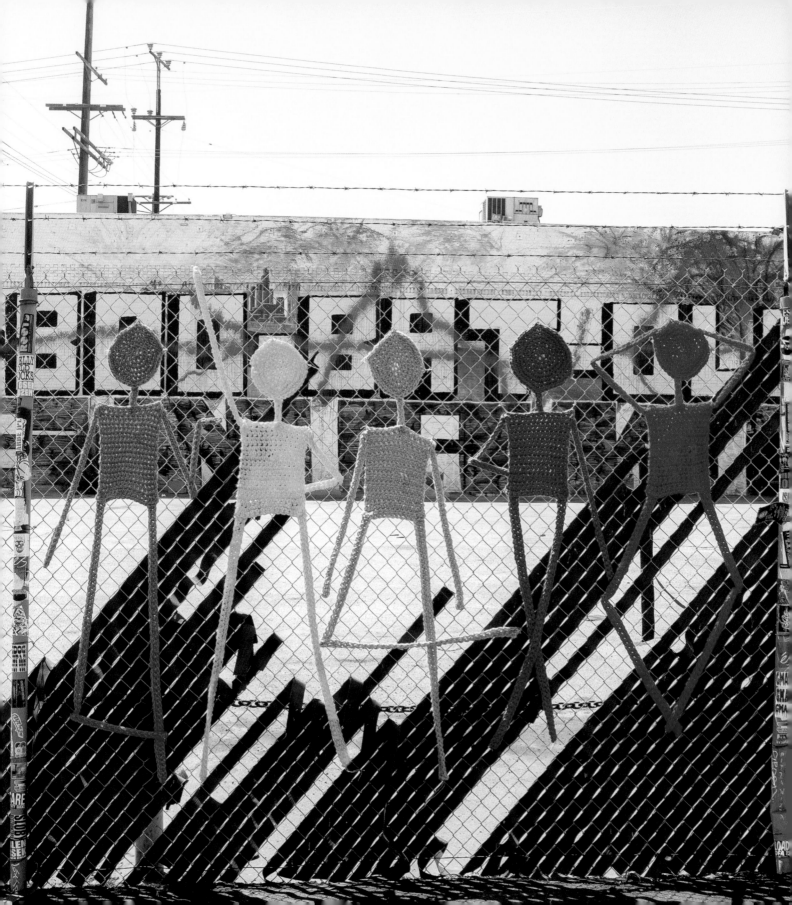

# stick figure

I grew up doing ballet, so I have had a lot of practice getting my body into different positions. Every shape that makes up the stick figure has a place and a purpose that mimics the human skeleton. When I am crocheting a stick figure, I like to imagine all the different ways I could position the arms and the legs so it has some personality. I use this project every time I crochet a person. Even when the final product looks very complicated and intricate, this project serves as the base.

## size

60 inches (152 cm) by 24 inches (61 cm)

## materials

**YARN:** 3 skeins of bulky weight in any color (variation: I like to single strand and use a bulky weight or double strand a medium weight for this project; I also like to keep the color and yarn consistent for all seven pieces that make up a stick figure)

Size US P/15 (11.5 mm) hook

Scissors

Hot glue gun

# here's how to make it

## HEAD: CIRCLE
Size: 10 inches (25 cm) in diameter

**Start**

**1.** Make a slip knot and ch 3.

**2.** Make 2 sc in the 2nd ch from the hook and 4 sc in the next ch.

**3.** Keep working your way in a circle and make 2 sc in the next stitch on the back of your ch.

**Round 1**
**1.** Make 2 sc in the next sc, make 1 sc in the next sc.
**2.** Repeat step 1 around.

**Round 2**
**1.** Make 2 sc in the next sc, make 1 sc in the next 2 sc.
**2.** Repeat step 1 around.

**Round 3**
**1.** Make 2 sc in the next sc, make 1 sc in the next 3 sc.
**2.** Repeat step 1 around.

Continue this pattern to make your circle larger until it has a diameter of 10 inches (25 cm). With every round you will add one more sc before making 2 sc in the next sc. Refer to the circle pattern (page 38) for more instruction.

## ARMS
Size: 25 by 1½ inches (63.5 by 4 cm)

**1.** Make a slip knot and ch until you reach 25 inches (63.5 cm).

**2.** Make 1 sc in the 2nd ch from the hook and 1 sc in each remaining ch.

**3.** Finish off.

**4.** Repeat steps 1–3 to make a second piece.

## LEGS
Size: 45 by 2 inches (114 by 5 cm)

**1.** Make a slip knot and ch until you reach your desired length of 45 inches (114 cm).

**2.** Make 1 sc in the 2nd ch from the hook and 1 sc in each remaining ch.

**3.** Turn, repeat step 2.

**4.** Finish off.

**5.** Repeat steps 1–4 to make a second piece.

## NECK
Size: 6 by 1½ inches (15 by 4 cm)

**1.** Make a slip knot and ch until you reach your desired length of 6 inches (15 cm).

**2.** Make 1 sc in the 2nd ch from the hook and 1 sc in each remaining ch.

**3.** Finish off.

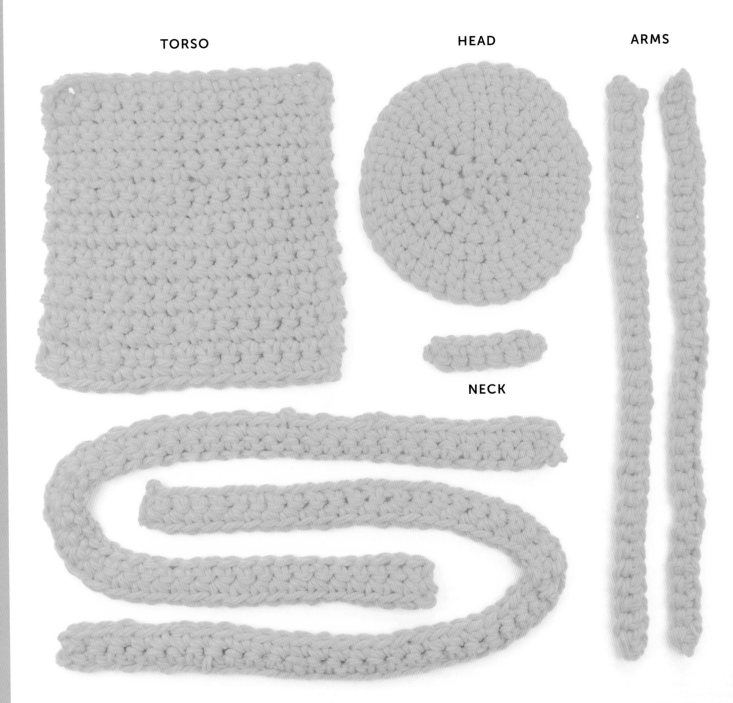

TORSO

HEAD

ARMS

NECK

LEGS

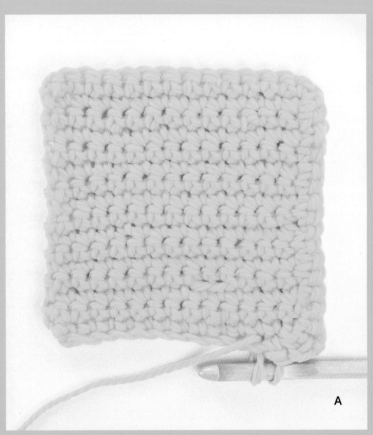

A

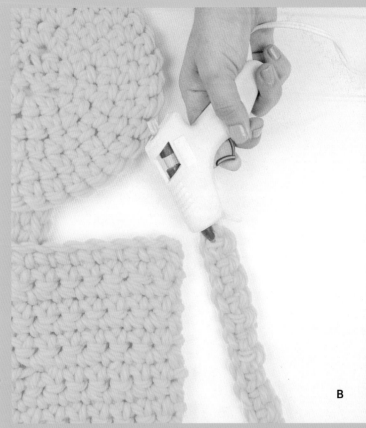

B

## TORSO: RECTANGLE
Size: 15 by 12 inches (38 by 30.5 cm)

**1.** Make a slip knot and ch until you reach 15 inches (38 cm).

**2.** Make 1 sc in the 2nd ch from the hook and 1 sc in each remaining ch.

**3.** Turn, make 1 sc in each remaining sc across.

**4.** Repeat step 3 until the width of your rectangle reaches 12 inches (30.5 cm). **(PHOTO A)**

5. Finish off.

## here's how to yarn bomb it

**1.** Glue the parts together to create a stick figure. Use the hot glue sparingly; a small dot goes a long way. **(PHOTO B)**

**2.** Cut strings and double knot them to the finished crochet piece. Make sure you have enough ties around the head and a string on every corner.

**3.** Tie it to a chain-link fence!

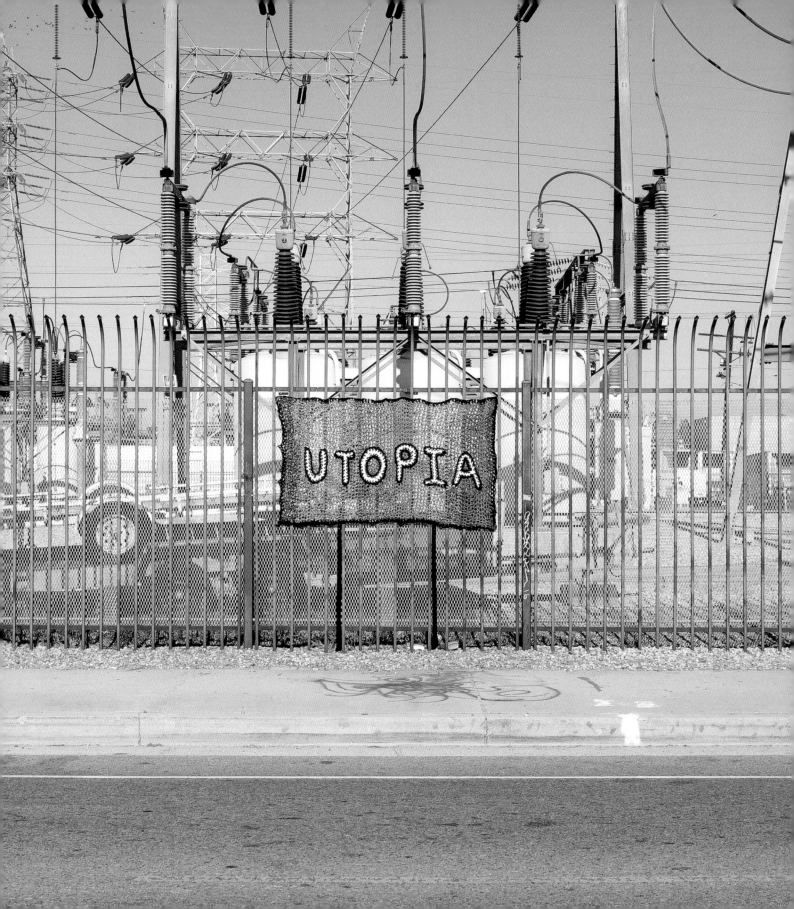

# colorful sign

Sometimes I get inspired by bright colors and rainbows, and other times I am inspired by events going on in the world. When I want to make people feel good and think at the same time, I like to use crochet letters to make a statement. A colorful sign is simply a large rectangle, so for this project I like to use all my leftover yarn and make something big. I keep the crochet process engaging by double-stranding my yarn and choosing combinations I never would have dreamed of. I stick to a color palette and constantly switch out different working yarns.

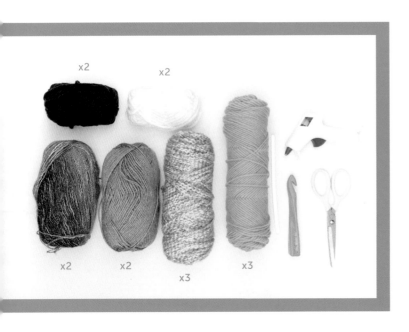

## size

Backdrop: 42 inches (106.5 cm) by 60 inches (152 cm)

## materials

### BACKDROP

**YARN:** 10 medium-weight skeins, double stranded

Size US S/35 (20 mm) hook

Scissors

### LETTERS

**YARN:** Bulky in white and black (number of skeins will depend on the number of letters needed)

Size US S/35 (20 mm) hook

Scissors

Hot glue gun or sewing needle and thread

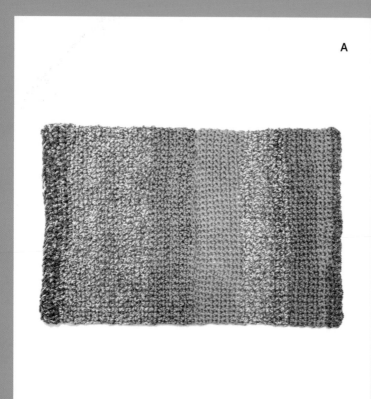

A

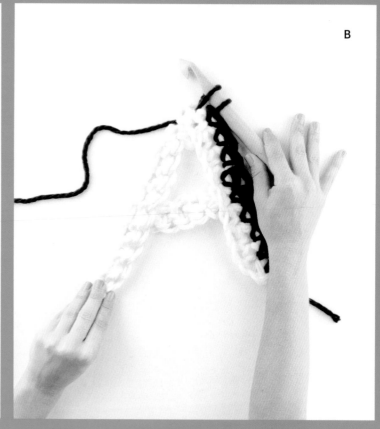

B

# here's how to make it

## BACKDROP

**1.** With two strands of medium-weight yarn, make a slip knot and ch until the length reaches 60 inches (152 cm).

**2.** Make 1 sc in the 2nd ch from the hook and 1 sc in each remaining ch.

**3.** Turn, make 1 sc in each remaining sc across. Change the color of working yarn as desired (see page 19).

**4.** Repeat step 3 until the width of your rectangle reaches 42 inches (106.5 cm). (**PHOTO A**)

**5.** Finish off.

## LETTERS

**1.** With white bulky yarn, crochet the letters of your message, following the alphabet patterns on pages 42–49.

**2.** Finish off.

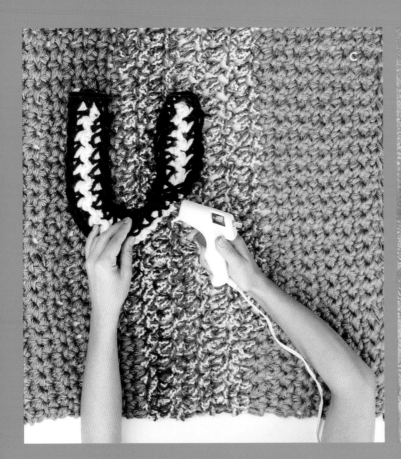

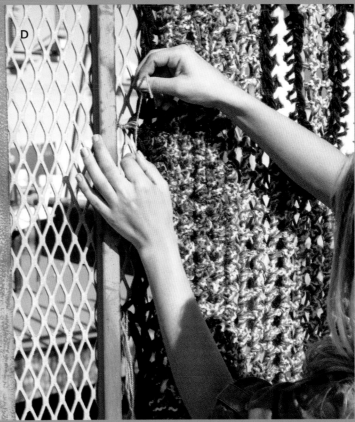

**3.** Glue or sew the letters together, then make them pop by crocheting around the outer and inner edges in black. This will keep the letters from getting lost against an especially colorful background. (**PHOTO B**)

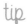

**tip**

If you want to make the letters smaller, use a smaller hook and a thinner yarn.

# here's how to yarn bomb it

**1.** Glue the finished crocheted letters to the crochet backdrop. (Attaching crochet letters to a crochet backdrop with hot glue is one of my favorite time-saving tricks.) (**PHOTO C**)

**2.** Cut strings and double knot them evenly around the finished piece of crochet. This piece can be heavy, so make sure to knot a string in each corner. (**PHOTO D**)

**3.** Attach to a chain-link fence (see page 31) or hang up on a wall or in a window.

# hyperbolic roses

**T**his project employs my favorite way to crochet a flower, because it involves mathematics. The principle is known as hyperbolic geometry, and the only way to make a model of it is through crochet. A paper published by Cornell University titled "Crocheting a Hyperbolic Plane" explains the math, but the actual crochet technique used to create a model representing it is not complicated at all. It's all about increasing and growing the working piece of crochet exponentially. To make your flower twist more, increase more. Because flowers come in all shapes and sizes, I regularly play around with different hook sizes and various yarns. I like to twist them up to look like roses and glue them together so they become three-dimensional.

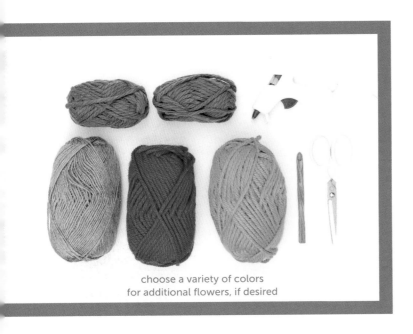

choose a variety of colors
for additional flowers, if desired

## materials

**YARN:** 1 bulky skein and 1 accent skein for flower in purple; 1 bulky skein for stem and leaf in green

Size US P/15 (11.5 mm) hook

Scissors

Hot glue gun

Push pins (optional)

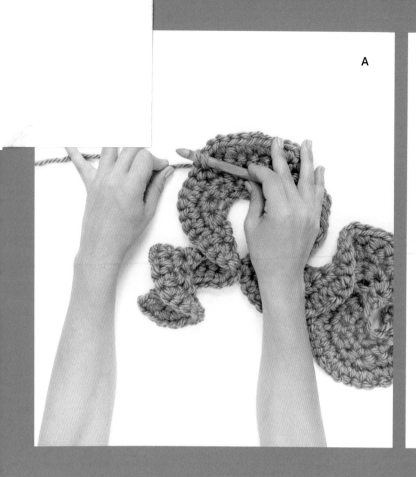

A

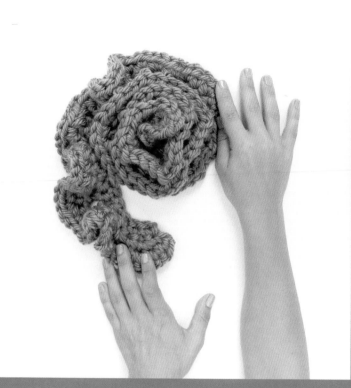

B

## here's how to make it

### FLOWER

**1.** With the bulky yarn, make a slip knot and ch until you reach 12 inches (30.5 cm).

**2.** Make 2 sc in the 2nd ch from the hook and 2 sc in each remaining ch.

**3.** Turn, make 2 sc in each sc across.

**4.** Repeat step 3 three times. (**PHOTO A**)

**5.** Change yarn to accent color (see page 19) and make 1 sc in each sc across.

**6.** Finish off.

**7.** To transform your piece of crochet into a flower, let the crochet fold upon itself and make it into a three-dimensional shape like a rose. Secure into place with dots of hot glue spread throughout. (**PHOTO B**)

*tip*

To make a different size flower, change anything—the hook size, kind of yarn, number of chains or rows. The more variety, the better!

### LEAF

**1.** With the green yarn, make a slip knot and ch until you reach 6 inches (15 cm).

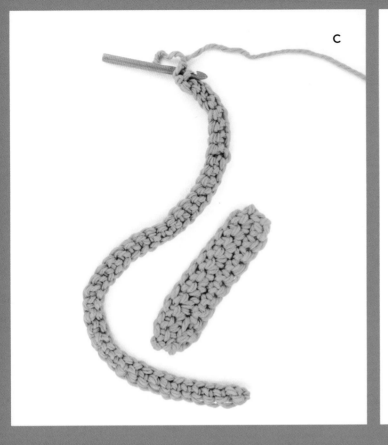

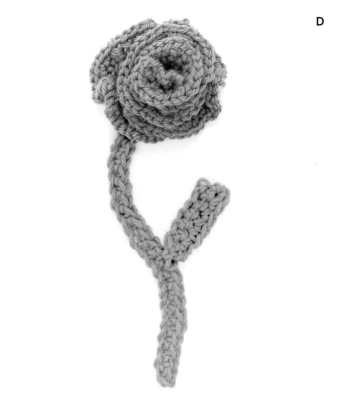

**2.** Make 1 sc in the 2nd ch from the hook and 1 sc in each remaining ch.

**3.** Turn, skip first sc, make 1 sc in each sc across.

**4.** Turn, make 1 sc in each sc across.

**5.** Finish off. (**PHOTO C**)

### STEM

**1.** With the green yarn, make a slip knot and ch until you reach 24 inches (61 cm).

**2.** Make 1 sc in the 2nd ch from the hook and 1 sc in each remaining ch.

**3.** Finish off. (**PHOTO C**)

## here's how to yarn bomb it

**1.** Glue the leaf and the finished crochet flower piece to the stem. (**PHOTO D**)

**2.** Use push pins to pin it to the wall or tie it onto a chain-link fence. I like to tie flowers onto a chain-link fence (see page 31). The more flowers, the better!

**3.** Before you tie it to the fence, double knot strings to the finished crochet piece. Make sure to tie plenty of strings around the flower, on the point of the leaf, and at the base of the stem. The more ties you add, the more specific you can be with the placement of the yarn bomb.

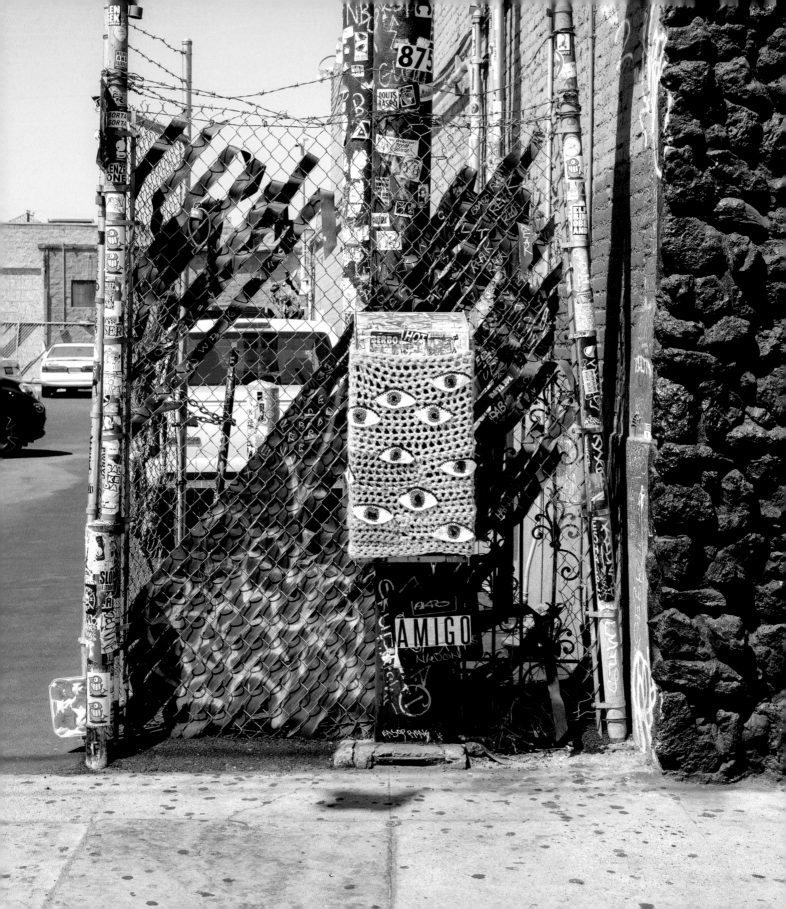

# pay phone wrap

**F**inding a pay phone in the wild is rare. As long as a pay phone no longer works, you can yarn bomb it. I decided to glue a lot of eyes onto my finished crocheted piece to turn the relic into an "eye phone." This project is pretty simple, so use it as a blank canvas and let your imagination run wild. If there is not a pay phone in your neighborhood, you can use the same pattern to yarn bomb a bench or your mailbox.

x3    x3

## size

36 inches (91 cm) by 42 inches (106.5 cm)

## materials

**YARN:** 3 skeins of medium and 3 skeins of bulky weight in shades of yellow

Size US S/35 (20 mm) hook

Scissors

Hot glue gun

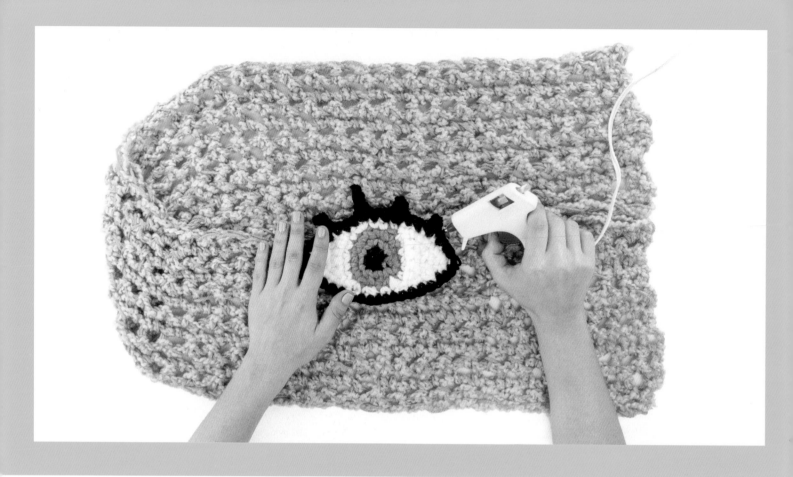

## here's how to make it

**1.** With two strands of medium-weight yarn in hand, make a slip knot and ch until the length reaches 42 inches (106.5 cm).

**2.** Make 1 sc in the 2nd ch from the hook and 1 sc in each remaining ch.

**3.** Turn, make 1 sc in each remaining sc across. For this step, if your working yarn runs out, change to a different shade.

**4.** Repeat step 3 until the width reaches 36 inches (91 cm).

**5.** Finish off.

## here's how to yarn bomb it

**1.** Glue a crochet appliqué or letters to the front of the finished crocheted piece. (**PHOTO ABOVE**) Get creative.

**2.** Wrap the finished crocheted piece around the pay phone. Weave it together on the back, double knotting extra strings if needed (see page 28).

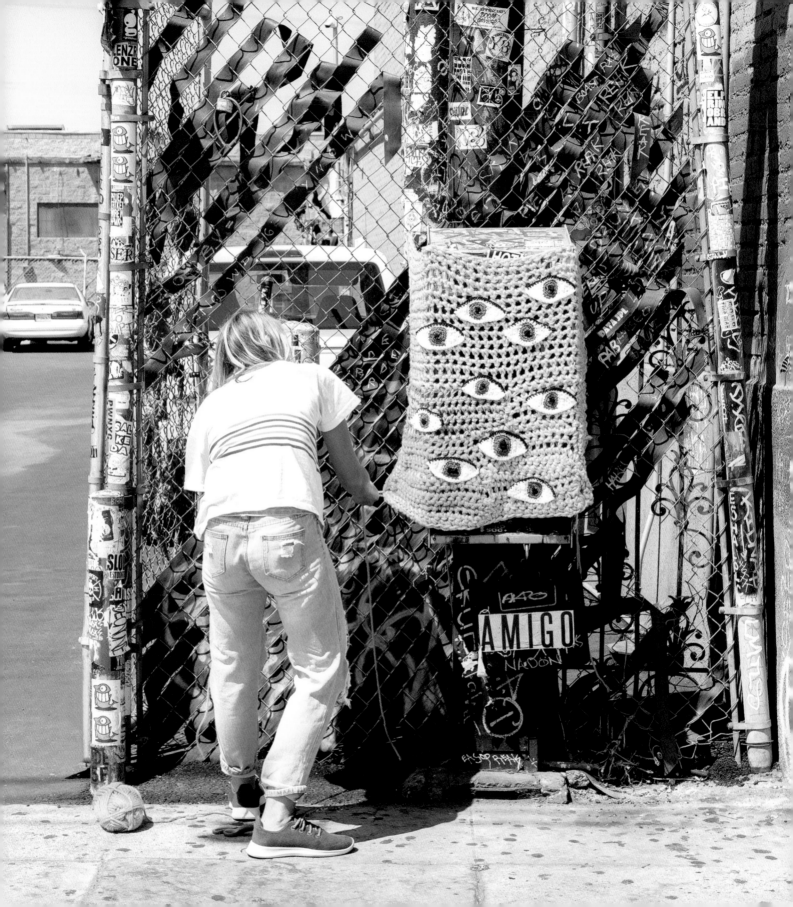

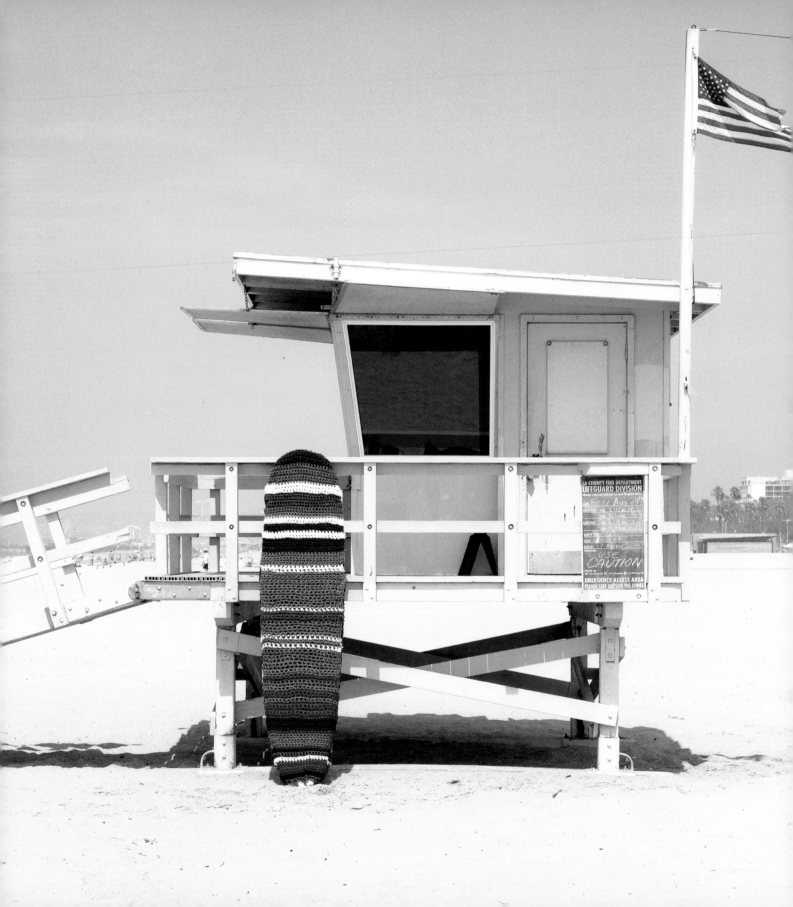

# surfboard cover

I was raised at the beach in Malibu, so the ocean has always been part of me. We tend to think of crochet as a fabric used primarily in the winter, but over the years it has become trendy in the summer too. Crochet bikinis were one of the biggest fashion statements of the 1970s, and they have remained in style to this day. This surf bag is meant to keep your surfboard clean and looking cool every time you hit the sand. If you do not have a surfboard, this pattern also makes a crochet sleeping bag to snuggle up in on the couch.

## materials

**YARN:** 8 skeins in a variety of colors and weights

Size US S/35 (20 mm) hook

Scissors

Measuring tape

Sewing needle and thread

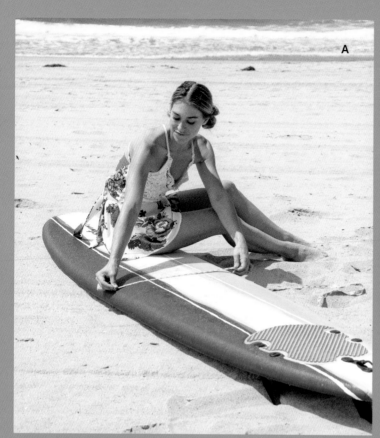

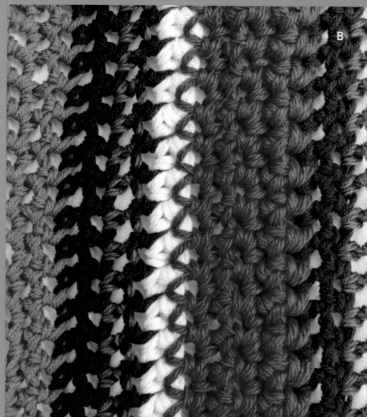

## here's how to make it

**1.** Measure your surfboard's width and length. Crochet stretches, so subtract about 3 inches (7.5 cm) from both measurements. Most surfboards are 18–20 inches (46–51 cm) wide and 72–84 inches (183–213.5 cm) long. **(PHOTO A)**

**2.** Make a slip knot and ch until you reach your desired width. Make 1 sc in the 2nd ch from the hook and 1 sc in each remaining ch.

**3.** Turn, make 1 sc in each remaining sc across.

**4.** Repeat step 3 until your rectangle reaches the desired length. For this step, change the color of your working yarn as desired (see page 19). **(PHOTO B)**

**5.** Finish off.

**6.** Repeat steps 2–5 to make a second piece.

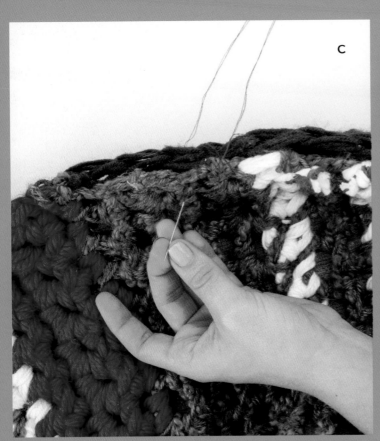

C

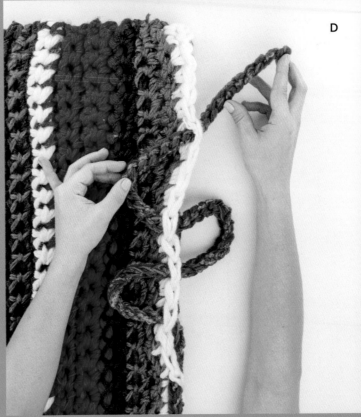

D

# here's how to yarn bomb it

Lay the two finished crocheted pieces on top of each other with the front sides touching. Sew together the outer edges with a piece of string using a whip-stitch, leaving only the top part of the surf bag open. (**PHOTO C**) Turn the bag right side out and weave a crocheted chain in and out of the loops at the top of the bag to make a drawstring closure. (**PHOTO D**) Slide your surfboard inside.

tip

If the bag is too big, sew the edges together tighter. You can also make a surf bag with the same techniques described in the project on page 55.

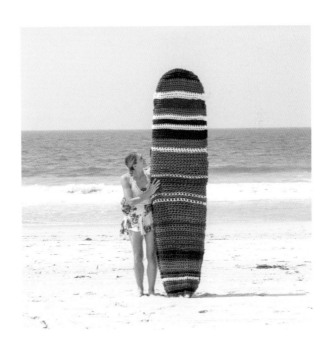

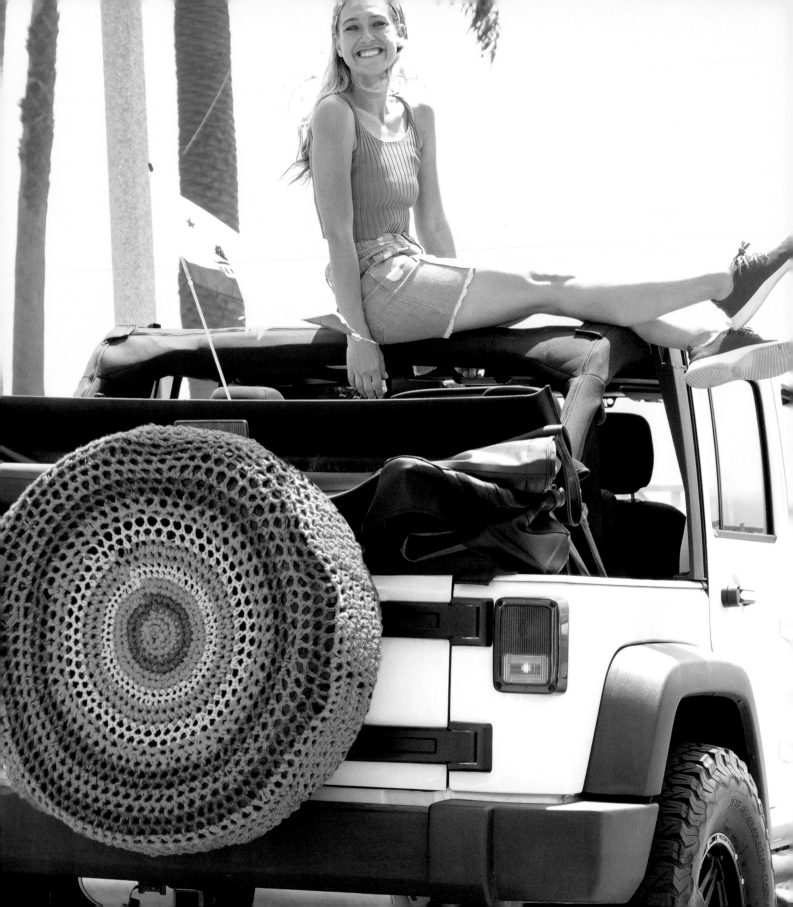

# tire wrap

If I could go back in time, I would have to make a pit stop and say hello to sixteen-year-old London. I was driving around in my first car, which coincidentally had a big tire on the back. I bought that car with the money I had saved selling scarves to friends and to boutiques around Los Angeles. Yarn bombing did not exist when I was in high school, but if it did, I would have yarn bombed my tire routinely. With this project, you will never again lose your car in a parking lot.

## size

About 48 inches (122 cm) in diameter

## materials

**YARN:** 3 medium skeins and 3 bulky skeins, double stranded, in shades of pink, orange, and red

Sizes US P/15 and S/35 (11.5 mm and 20 mm) hooks

Scissors

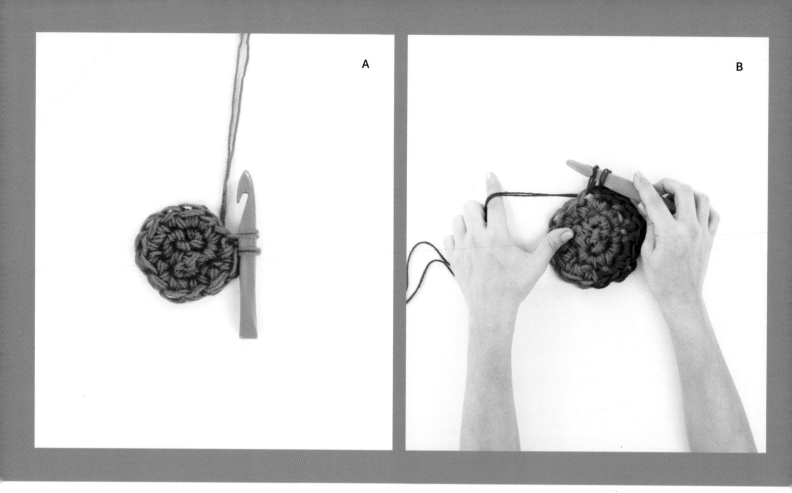

# here's how to make it

**1.** Using a size P/15 (11.5 mm) hook and two strands of medium-weight yarn in the color of your choice, make a slip knot and ch 3.

**2.** Make 2 sc in the 2nd ch from the hook and 4 sc in the next ch.

**3.** Keep working your way around in a circle, and make 2 sc in the next stitch on the back of your ch. **(PHOTO A)**

### Round 1
**1.** Make 2 sc in the next sc, make 1 sc in the next sc.
**2.** Repeat step 1 around. Change color between

rounds and work your way through the various colors in your palette (see page 19). **(PHOTO B)**

### Round 2
**1.** Make 2 sc in the next sc, make 1 sc in the next 2 sc.
**2.** Repeat step 1 around. Change color. **(PHOTO C)**

### Round 3
**1.** Make 2 sc in the next sc, make 1 sc in the next 3 sc.
**2.** Repeat step 1 around. Change color.

### Round 4
**1.** Make 2 sc in the next sc, make 1 sc in the next 4 sc.
**2.** Repeat step 1 around. Change color.

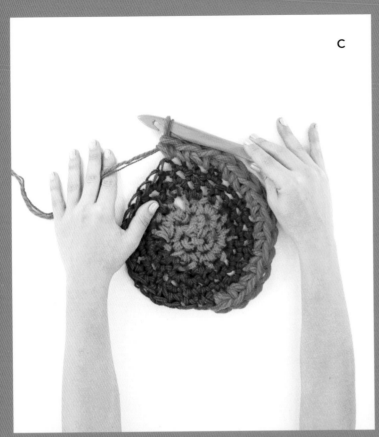

C

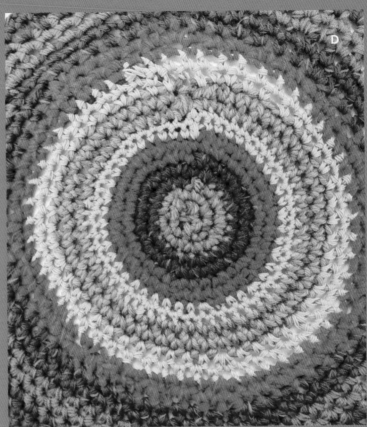

D

### Round 5

**1.** Make 2 sc in the next sc, make 1 sc in the next 5 sc.
**2.** Repeat step 1 around. Change color.

Change to a size S/35 (20 mm) hook. Continue this pattern until your circle reaches 48 inches (122 cm) in diameter. (**PHOTO D**)

With every round, add 1 more sc before making 2 sc in the next sc.

**tip**

Once you get past round 6 you may not need to make 2 single crochets in any stitch. Refer to the circle pattern (page 38) for tips on keeping your circle flat.

## here's how to yarn bomb it

Knot two strings to the top of the finished crochet circle, then weave the strings in and out of the crochet loops around the perimeter. Pull the edges closer together as you go. Depending on how the tire is connected to the car, you may have to modify the way you weave the strings in and out.

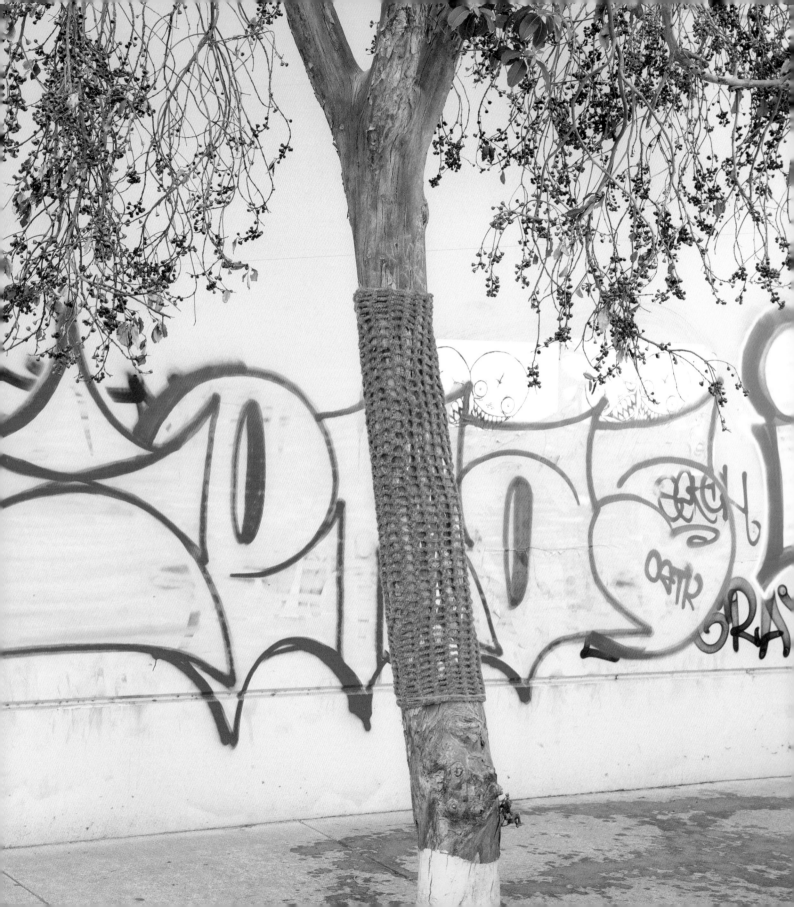

# tree wrap

**M**y very first yarn bomb was a tree wrap. I had no idea what I was doing, and I never could have expected how it would transform my life. I hung that first tree wrap outside my apartment in Brooklyn. I couldn't believe that after a couple of days it was still up! I thought someone would pull it down or the yarn would get dirty. Instead, my neighbor told me how much it brightened her and her granddaughter's days. I had no idea a little bit of crochet in an unexpected place could change someone's mood. My first tree wrap stayed up for more than two years. The crochet is no longer there, but the tree is thriving!

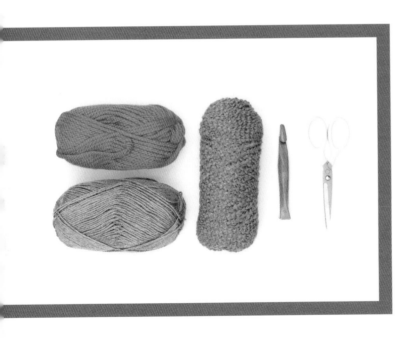

## size

24 by 60 inches (61 by 152 cm)

If there is a particular tree you would like to yarn bomb, measure its length and circumference so you can make your tree wrap fit like a glove. The circumference measurement is the width of your rectangle.

## tip

Because crochet stretches so much, subtract about 3 inches (7.5 cm) from your width measurement.

## materials

**YARN:** 1 medium skein and 1 bulky skein in pink, double stranded

Extra yarn for yarn bombing (optional)

Size US S/35 (20 mm) hook

Scissors

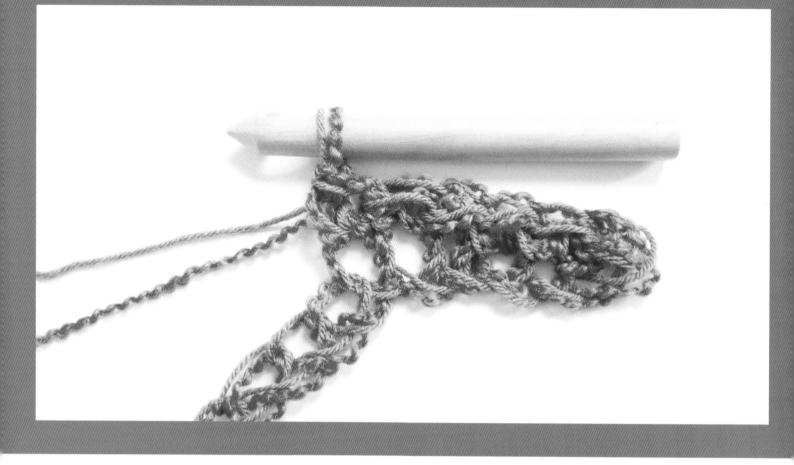

## here's how to make it

**1.** With one strand each of medium-weight and bulky yarn in hand, make a slip knot and ch until the length reaches 60 inches (152 cm). **(PHOTO ABOVE)**

**2.** Make 1 sc in the 2nd ch from the hook and 1 sc in each remaining ch.

**3.** Turn, make 1 sc in each remaining sc across.

**4.** Repeat step 3 until the width of your rectangle reaches 24 inches (61 cm), or the circumference of your tree.

**5.** Finish off.

## here's how to yarn bomb it

Use the "weave it" technique found on page 28. Start at the top of the tree wrap and weave pieces of yarn back and forth, creating an X pattern down one side of the tree. When finished, cut all loose ends.

*tip*

Sometimes I secure the top and the bottom of the crochet by wrapping extra yarn around the tree.

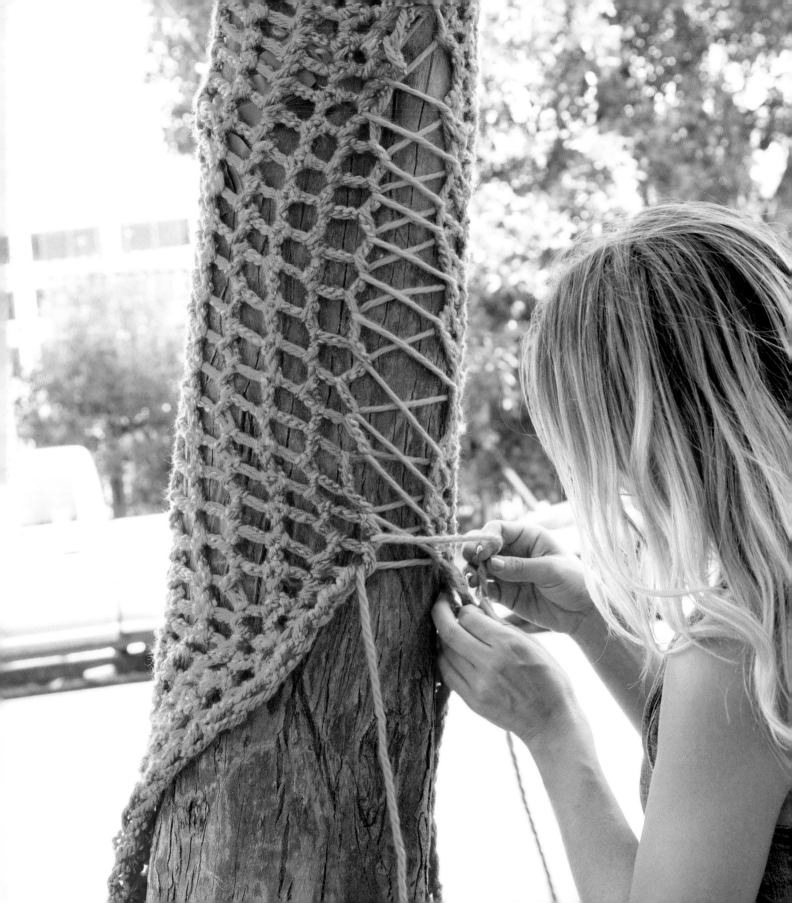

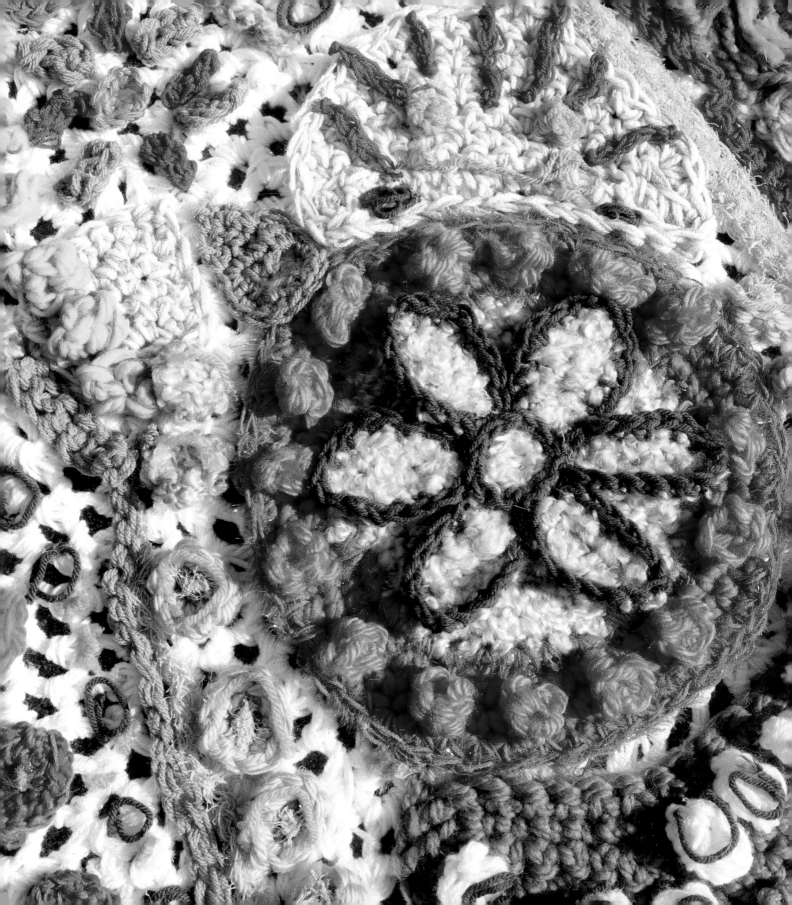

# YARN
# BOMBS

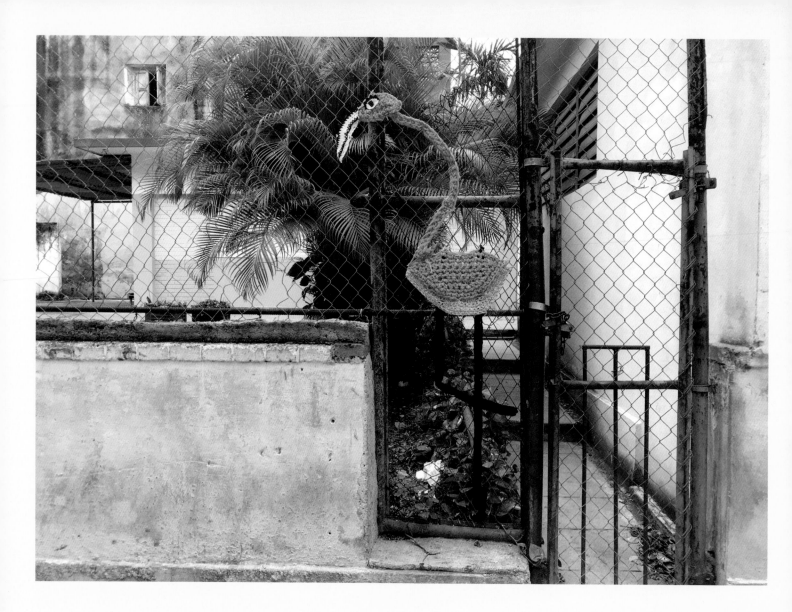

# flamingo

## HAVANA, CUBA

I hung this simple crochet flamingo in Havana, Cuba. I wasn't sure how the locals would take to yarn bombing, but it did not take long before I got to see their reactions. I was overwhelmed with delight when I heard the word *flamingo* spoken up and down the street. People were bringing friends and family over to see and touch what had just appeared on the block. No one had ever seen this type of art. In fact, other than political or public-service graffiti, street art was just beginning to emerge in Cuba. This little flamingo was not a flashy yarn bomb, but I will always cherish the memories of the smiles and love the yarn bomb created in the community.

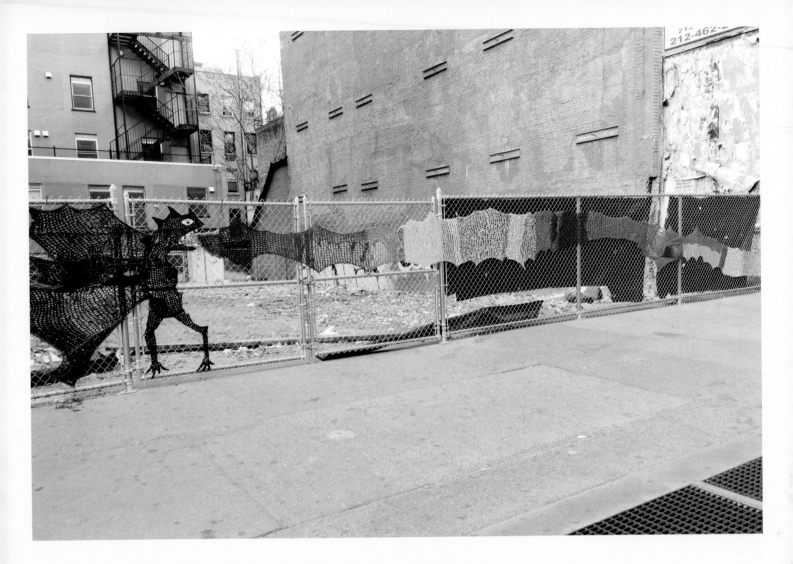

# dragon

## 6TH AVENUE AND WEST 14TH STREET, NEW YORK

It's always a plus when I hang street art in a place that I walk past frequently. This dragon has a story as long as its flame. About two weeks after I hung the dragon, I noticed the yarn had been pulled a bit, so I went to take a closer look. A man asked if I was the artist. He shared that the night before, the dragon had been taken down and thrown over the fence. He and his kids decided to come back, jump the fence, and use zip ties to put the dragon back up. It was positioned slightly differently, but because of the kindness of random strangers, the dragon was not slayed. A few weeks later, the dragon had been completely stripped from the fence. That is not a rare occurrence in the yarn bombing world, but the response from the neighborhood was unexpected. In place of the dragon was a sign that read, "Where is my dragon?" I was completely astounded by the love and concern the community had for this piece.

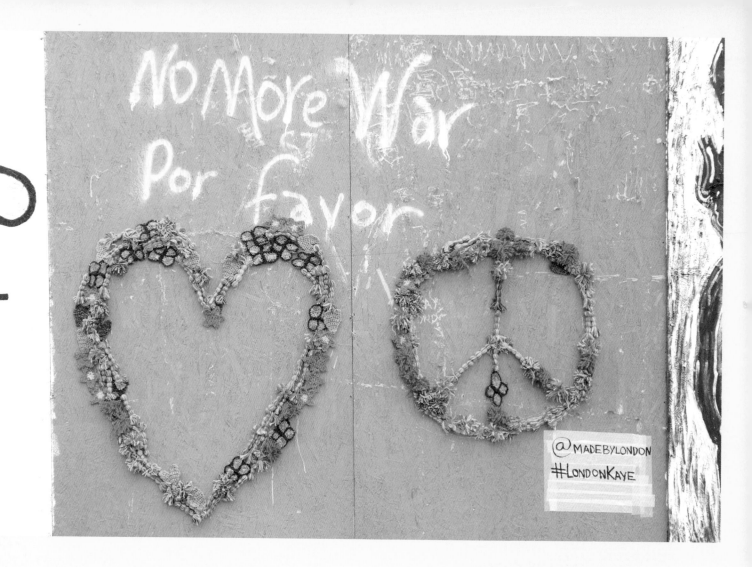

## no more war

**BUSHWICK, BROOKLYN**

Living in Bushwick, I felt like every time I walked out my door I was instantly in the center of the street art world. I had permission to use this wall, and the graffiti statement "No More War Por Favor" was there before I attached the crochet. I made this piece by gluing pompoms, tassels, flowers, and butterflies into shapes. I was inspired by the lightness and power of the phrase. If only peace and love were the basis of everything.

## water pipe

**201 WYCKOFF AVENUE, BROOKLYN**

Crochet water leaking out of a pipe onto the streets of Brooklyn is one of my signature pieces. For about one year, every month I attached new crochet leaking out of the same water pipe. Each time I created something for the pipe, I felt like I had to outdo the prior piece. This process forced me to stretch my creativity—not just because I wanted to make each one better than the last, but also because of the conversation it stirred in the neighborhood.

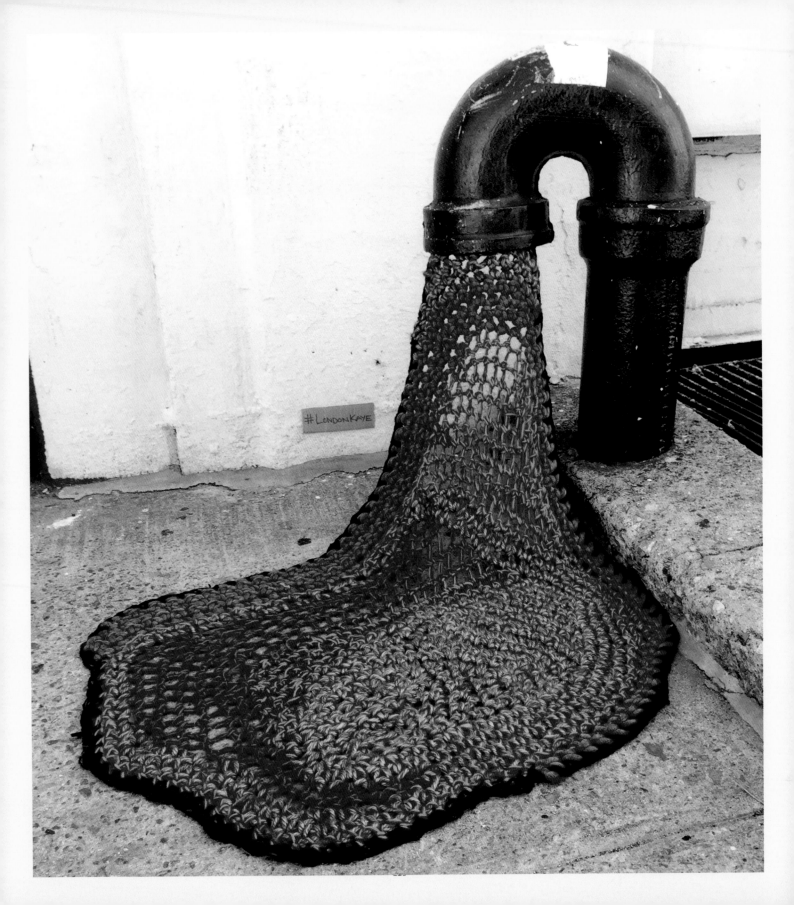

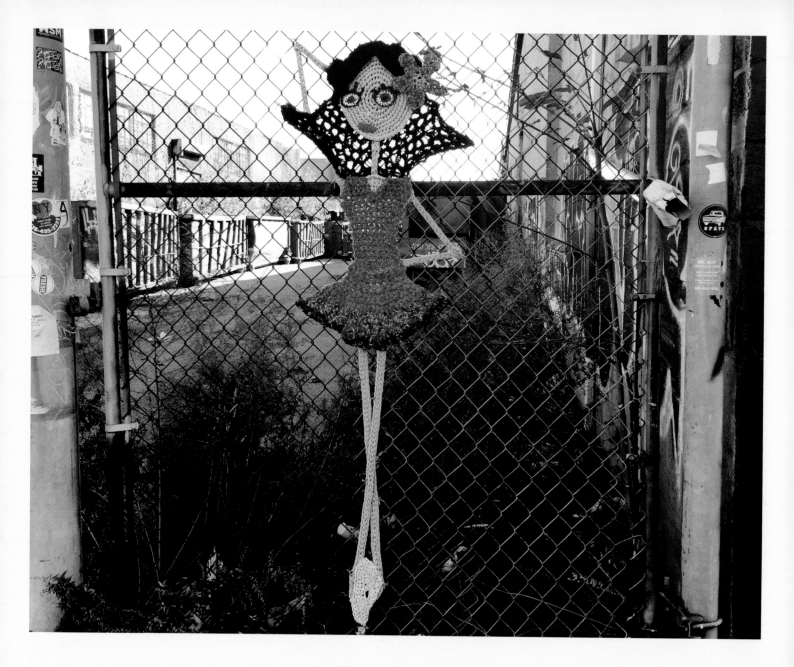

# lola the ballerina

## HALSEY STREET, BROOKLYN

Since I grew up dancing and claim to be a bunhead, ballerinas are at the top of my list of things to crochet. I love manipulating the limbs of dancers so they are poised with perfect technique, and the lightness of crochet lends itself well to liveliness and grace. Lola has popped up more than once throughout the years and has led a troupe of dancers around the globe.

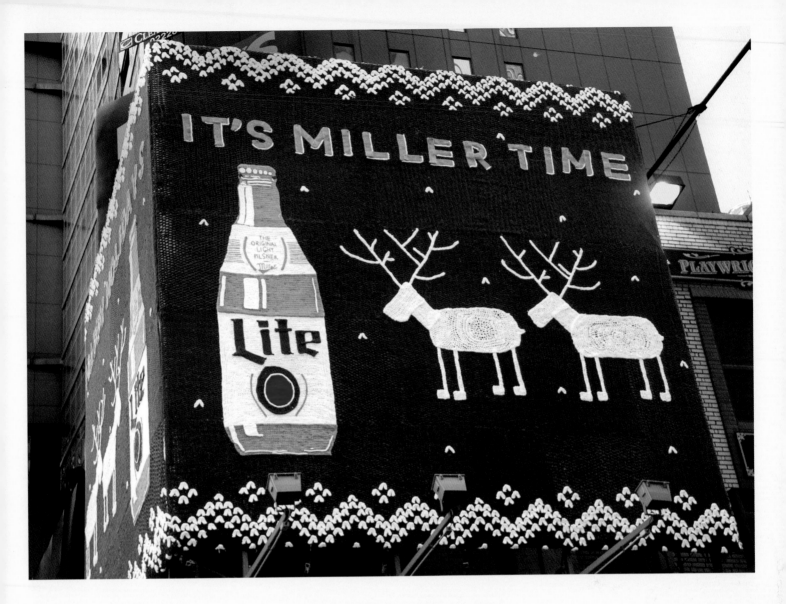

## miller lite billboard

**TIMES SQUARE, NEW YORK**

The Miller Lite billboard was 50 feet (15 m) by 25 feet (7.5 m) and hung in Times Square for more than one month during the holiday season of 2015. Every single crochet stitch was made by hand and tight enough to withstand a New York City winter with no protective covering. I had three weeks to complete the project and had to work around the clock to make the deadline. This was exhausting, but well worth it. It was thrilling to look up at something so grand that I created by hand. This was the very first crochet billboard, and the exposure was tremendous. Aside from its grandeur, what makes this project stand out is that it allowed me to quit my day job and focus entirely on yarn bombing.

**yarn bombs**

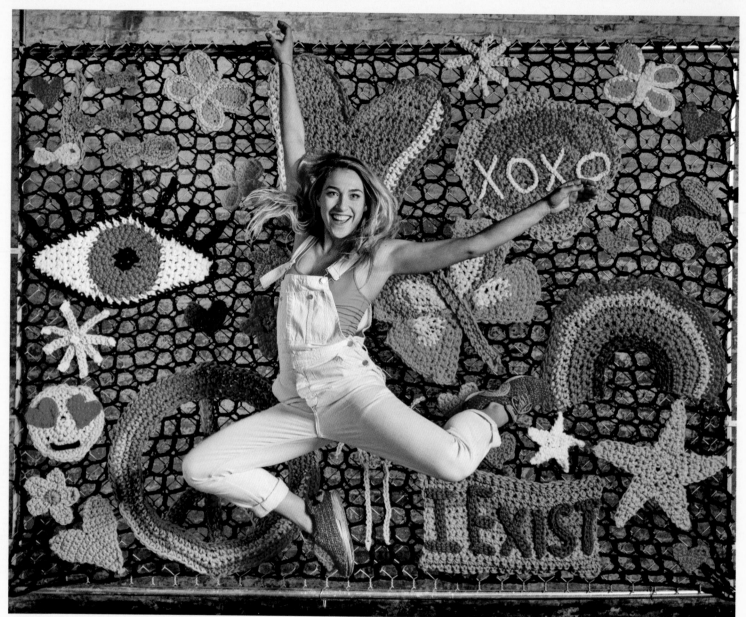

PHOTOGRAPH BY LION BRAND YARN

# lion brand yarn and london kaye

## 34 WEST 15TH STREET, NEW YORK

Lion Brand Yarn is one of the biggest yarn manufacturers in the world. I partnered with them to create special yarn and crochet hooks made specifically for yarn bombing. The hooks are made with my patented twist design, and the yarn is meant for both outdoor and indoor projects. I can't thank Lion Brand enough for all of the support they have given me.

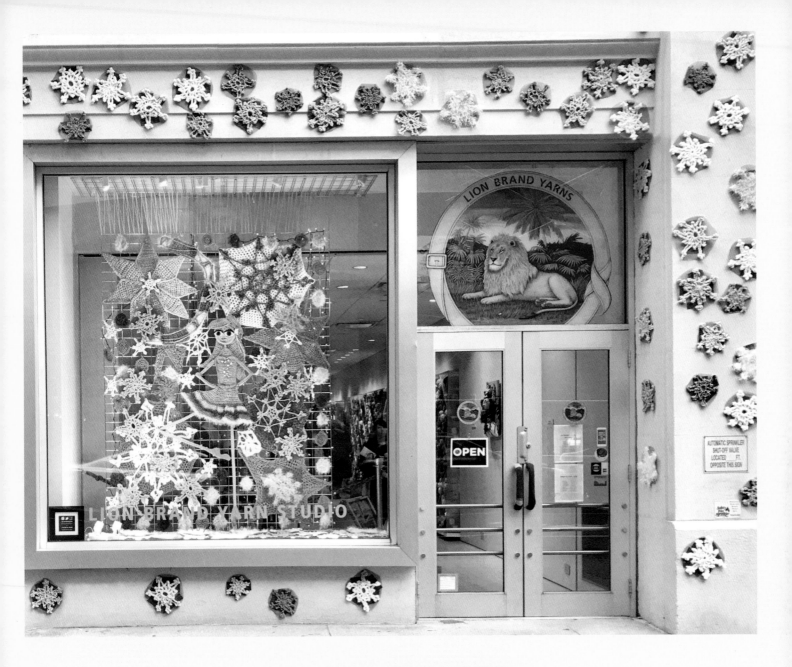

# lion brand yarn studio

### 34 WEST 15TH STREET, NEW YORK

This winter window display highlighted the yarn Lion Brand offers. They make yarn in so many colors, textures, and weights that it produces the most beautiful results when crocheted together in unusual ways! Not only was this window display special because of the crochet art inside; it also leaped outside, covering the facade of the building in snowflakes. I created a different design for every season throughout the year.

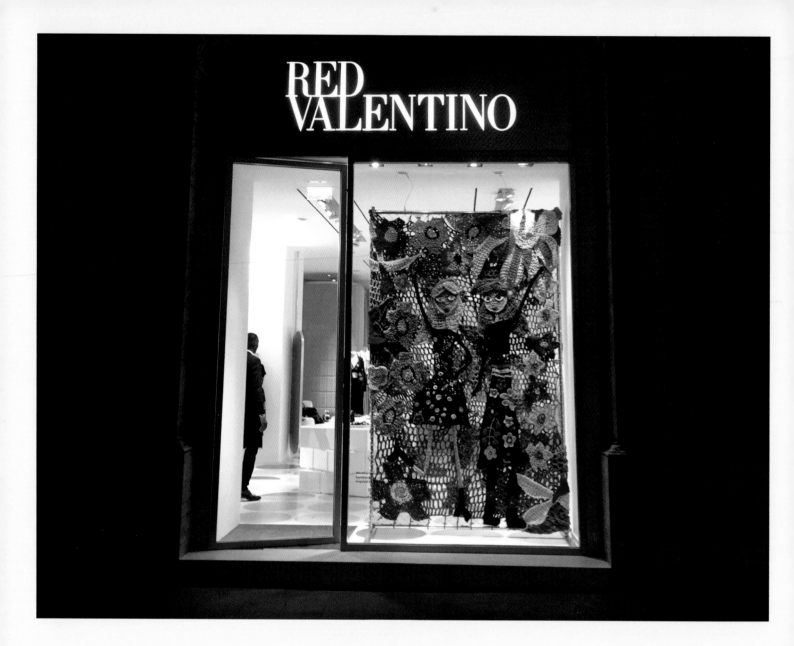

# redvalentino

**ROME, ITALY**

When I first received an email from the House of Valentino, I thought it was a mistake. I began the collaboration by crocheting fourteen window displays around the world for REDValentino. To hang the work, we brought in chain-link fencing to mimic my street art, which was a stark contrast to Valentino's posh boutiques. The response was so positive that I was asked to create a capsule collection. London Kaye for REDValentino was part of its 2016 clothing line.

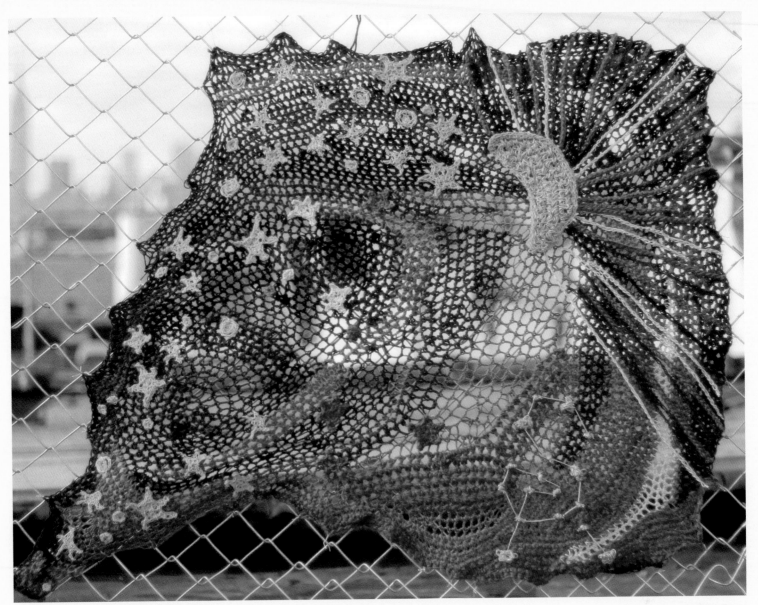

# starry nite

## BROOKLYN

This piece is a custom commission that ultimately helped stretch my skills as an artist. Instead of diving in with a crochet hook, I first sketched my vision on paper and presented it to the client. I now use this step regularly in my process. I find that sketching out my ideas is a good way to share with others, so they can have a clearer idea of what I imagine the final piece will look like. For this piece, I pulled colors straight from Van Gogh's *The Starry Night* and used yarn that sparkles for added detail in the stars—just what the client wanted.

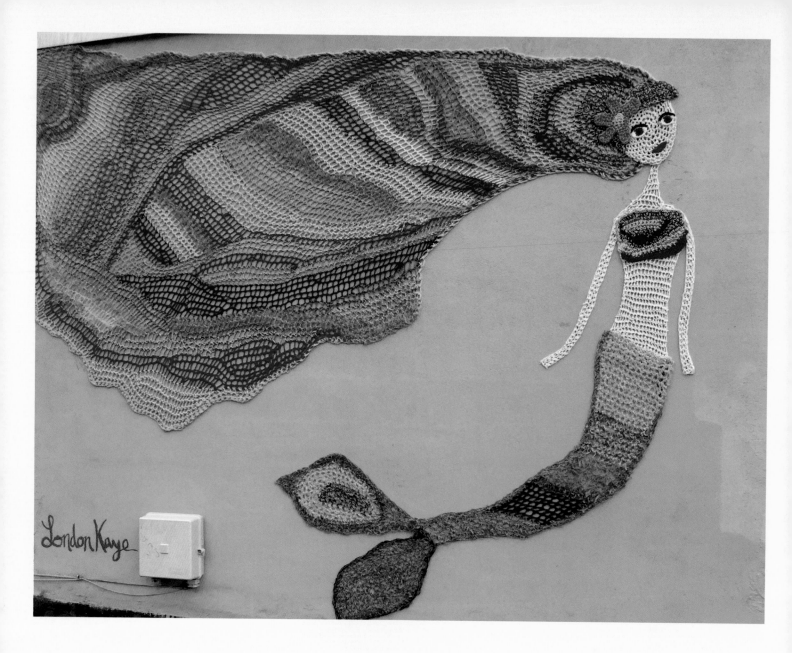

# mermaid

## SUGARLIFT IN BUSHWICK, BROOKLYN

For fun, I spent more than ten hours crocheting the mermaid's hair while blindfolded, and the final result was worth every minute. Without looking, I would pick two random skeins of yarn from a pile and begin crocheting. When I felt the moment was right, I would reach for my scissors, change the color of yarn, and continue crocheting, never opening my eyes. It was an interesting experiment because I realized I can intuitively crochet.

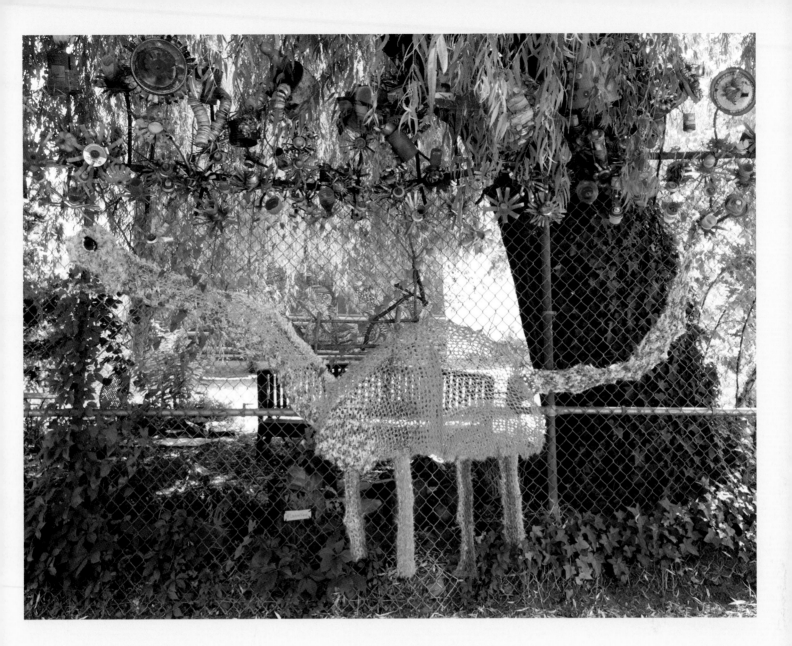

# dinosaur

**9TH STREET COMMUNITY GARDEN, EAST 9TH STREET AND AVENUE C, NEW YORK**

When I was making this dinosaur, I did not have a particular installation location in mind. So when it was time to go and yarn bomb, I found a fence in the moment that looked pretty good. Halfway through the installation, another fence across the street caught my eye—I moved things immediately, and the dinosaur found its home. It stayed on that fence for more than a year, which is a long time for a yarn bomb.

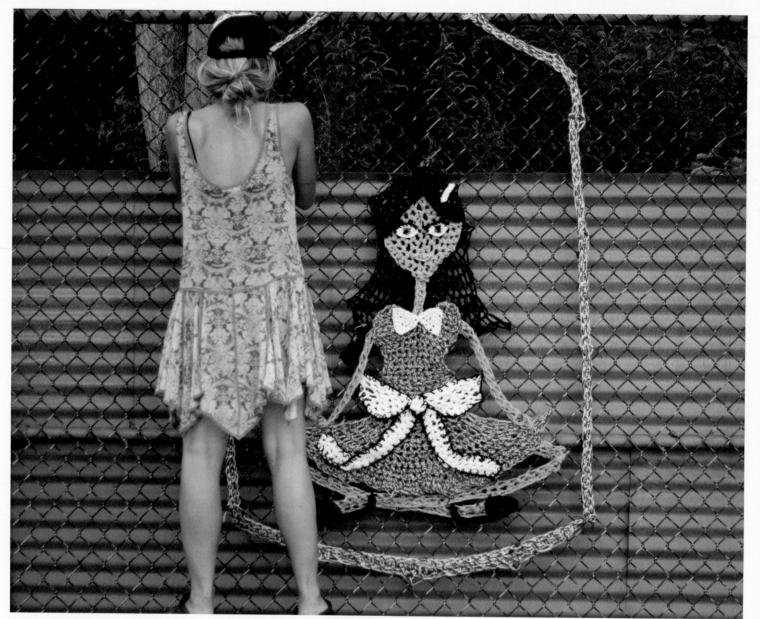

PHOTOGRAPH BY JOHN PATE HAMILTON

# meditation

### BUSHWICK, BROOKLYN

I am always most at peace when I am either dancing or crocheting because these activities allow my mind to slow down, and I can quiet the internal chatter. When I was creating this piece, I was in a place in my life where I was making a lot of big decisions. Instead of getting overwhelmed, I took a breath and crocheted.

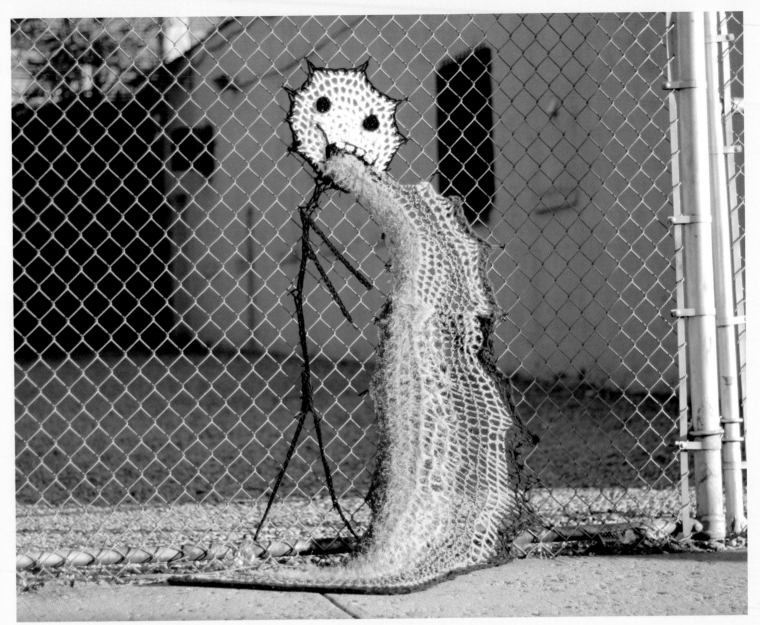

PHOTOGRAPH BY JOHN PATE HAMILTON

# meme

## BUSHWICK, BROOKLYN

Sometimes the simplest things have the biggest impact. The meme idea came to me in a snap and quickly I crocheted it during a snowstorm in just a few hours. What I love about this meme is that it is a good metaphor for my work because I continually remind myself to look at the bright side of life. What we focus on, we become.

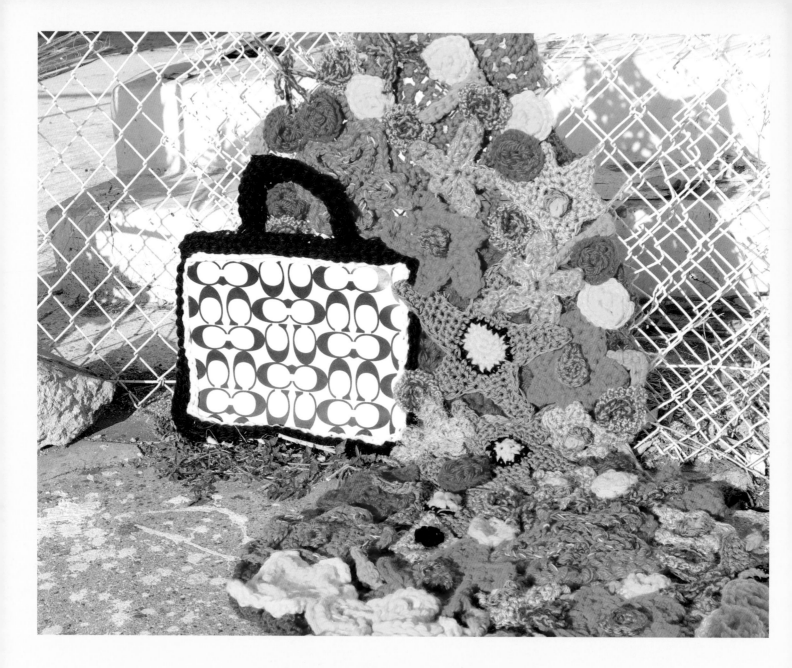

# coach street art campaign

**NEW YORK**

Coach selected a group of street artists to work on a guerilla marketing campaign in New York City. I was honored to be one of the artists chosen to transform the traditional Coach print from 1951 into something fresh and new. The original piece I crocheted was hung and photographed. Posters were printed and spread around New York City, bringing attention to the brand in a new way.

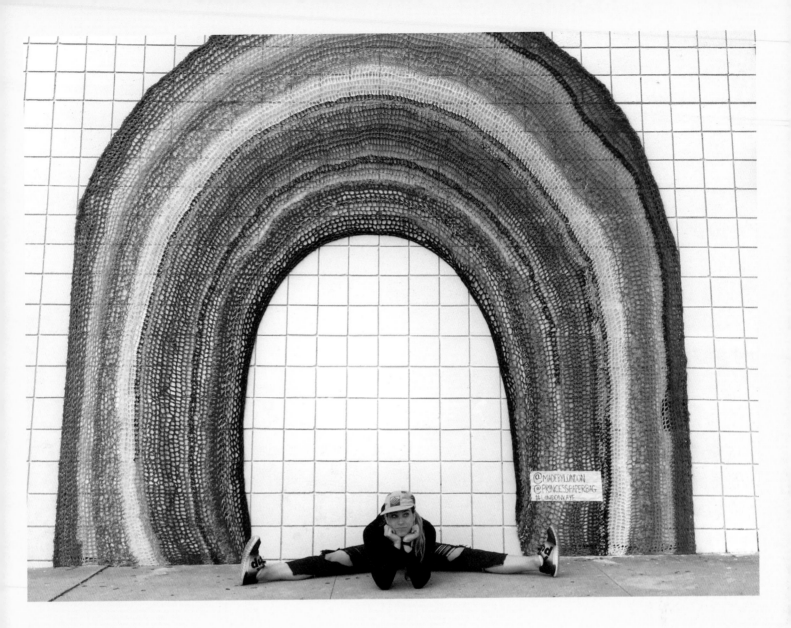

# rainbow

### 8050 MELROSE AVENUE, LOS ANGELES

One of my favorite parts of the yarn bombing process is what happens after I hang up a piece. The people passing by do not expect to see hanging yarn, so I never know what to expect from them. I get the best reactions when people get to interact with the crochet art. The Melrose Rainbow is interactive and has become a staple of the Instagrammable street art found in Hollywood. It is photographed hundreds of times every day and hopefully brings in even more smiles. Sometimes there are lines of people waiting to take their picture in front of the rainbow. This warms my heart.

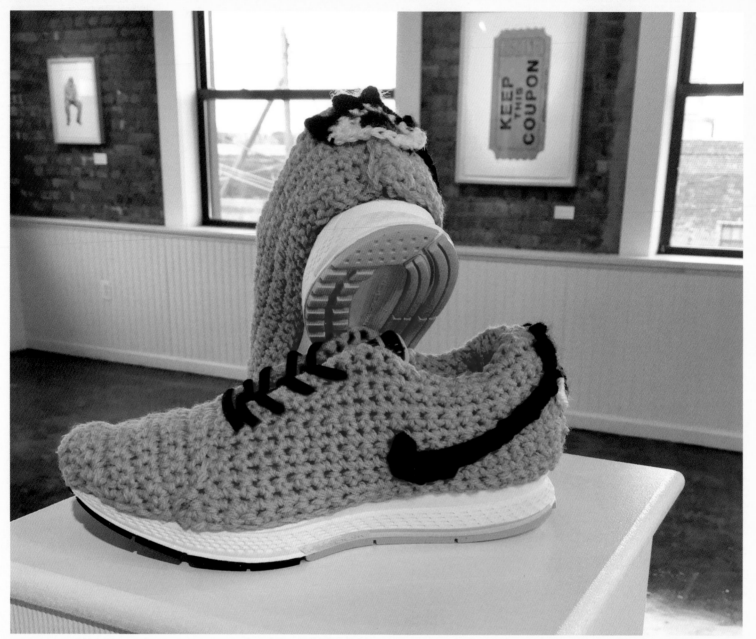

# crochet nikes

## SUGARLIFT IN BUSHWICK, BROOKLYN

I crocheted these sneakers for my first art show at the Sugarlift gallery. It was an eye-opening moment seeing sneakers on display as a piece of art. Prior to that, I'd looked at my crochet Nikes simply as flashy footwear. Each pair of shoes came with a tag of authenticity that I signed and stamped. Everything was very official.

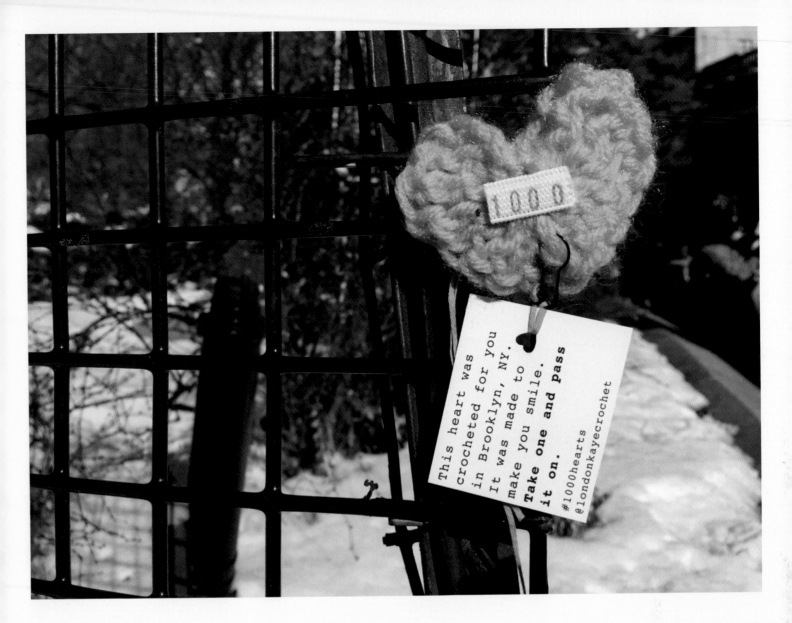

# 1,000 hearts

## UNION SQUARE, NEW YORK

It seems apropos to spread love on Valentine's Day. I launched my 1,000 Hearts project on February 14, 2015, to see how far and fast love can spread. By numbering each heart and adding a tag that read, "This heart was crocheted for you. Take it and pass it on," I was hoping to (somewhat) keep track of the hearts' travels from recipients posting online. Since the first one thousand hearts were hung on a fence in Union Square on a cold Valentine's Day, I have continued to randomly pass out hearts. My current count is more than five thousand. I believe these hearts make the world a more loving place.

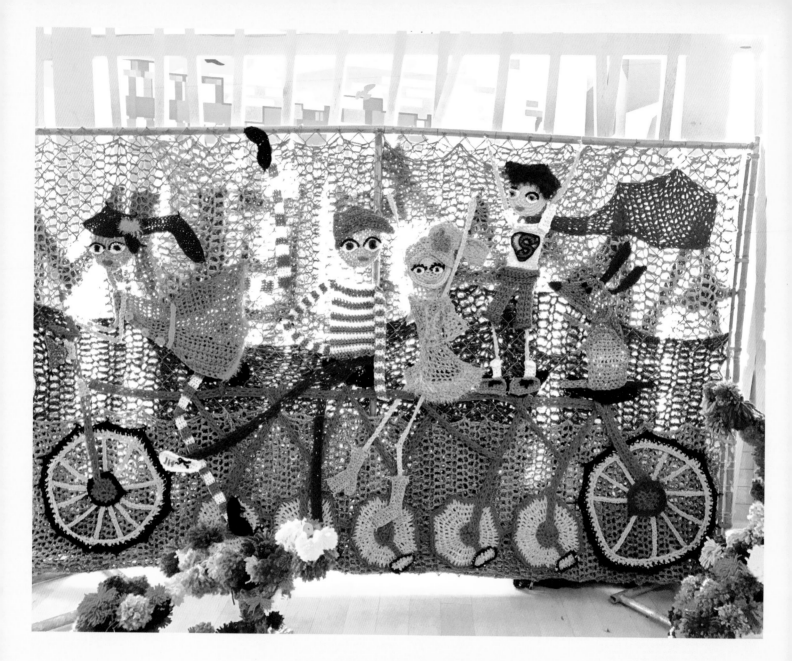

# scott family amazeum

## BENTONVILLE, ARKANSAS

The Amazeum is an interactive children's museum where kids get their hands dirty and let their imaginations run wild through the arts and sciences. It's the perfect place for bright colors and soft yarn. Lion Brand Yarn sponsored this mural, which is meant to inspire kids to work with yarn in a new way. I held a yarn bombing workshop and had the kids make pompoms to attach to the mural as a final touch.

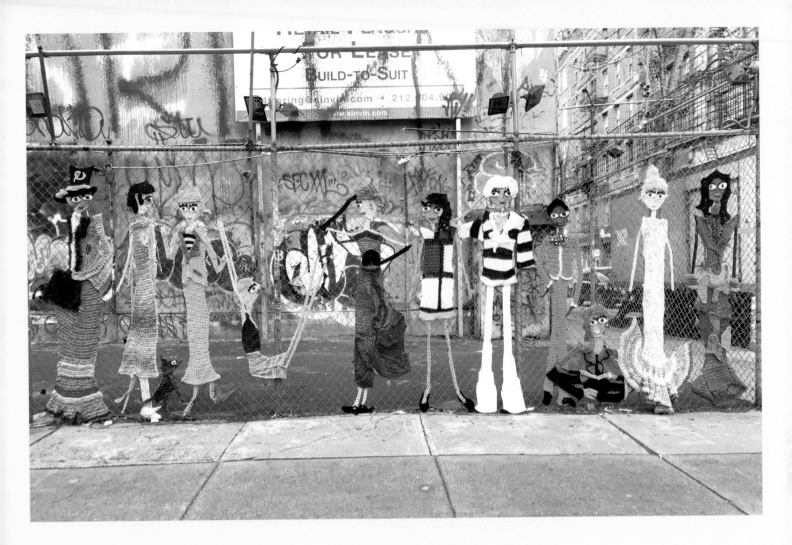

# fashion through the decades

**SOHO, NEW YORK**

I hung this piece at 6 a.m. in Soho on International Women's Day while being filmed by National Geographic. It was freezing cold outside, and I was wearing a dress with stockings because I thought it would look good for the video. I quickly realized this was a big mistake. The subzero temperatures and gusting winds made it nearly impossible to hang this up. On top of that, I had to take off my gloves to tie the piece to the fence. I absolutely loved this piece, though, and was so thankful that National Geographic was covering it. It features twelve girls wearing different outfits from actual *Vogue* magazine covers. Each girl sports a look from a different decade, beginning with 1910 and continuing to the present day. I spent weeks working on this project only to have it disappear after a couple of hours in public. Sharing art with the world is special and exciting, but as a yarn bomber, I have to accept that I may spend more time making a piece of crochet than it spends hanging in a public space.

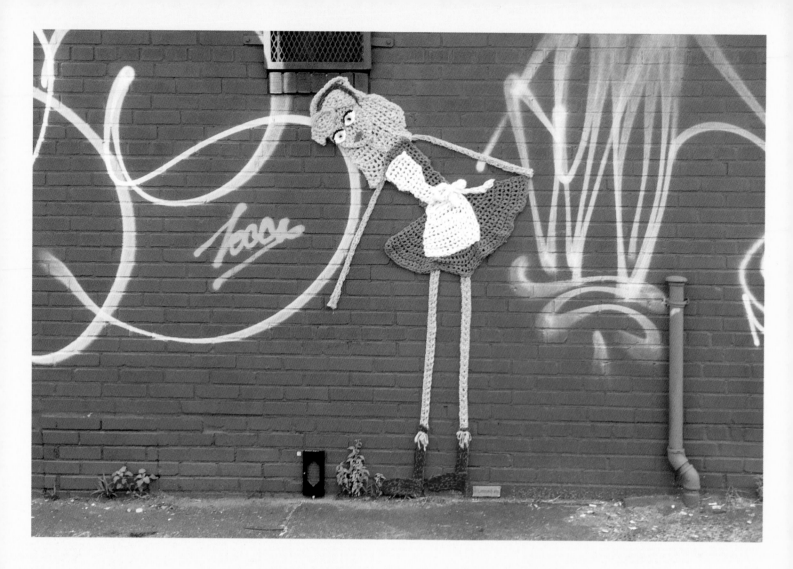

## alice and the little door

**BUSHWICK, BROOKLYN**

I enjoy making art that interacts with the world around it, so when an opportunity arose to collaborate with an artist hiding little doors around New York City, I had to say yes. The little door immediately reminded me of Lewis Carroll's classic *Alice's Adventures in Wonderland*. I crocheted Alice and placed her pointing down to the little door at the base of the wall. How enchanting to imagine shrinking down into a peculiar world of whimsical fantasy.

## save the humans

**GREENPOINT, BROOKLYN**

I made this piece for the television show *High Maintenance* on HBO. I did not know the story line of the episode when they asked me to share a few ideas of what I could make. It wasn't until I was watching the show live that I learned the crochet art makes a witty commentary on the state of America in the year referenced in the show.

# delivery.com

## DUMBO, BROOKLYN

Delivery.com was the first commercial I worked on, and it was seen across the country. This job entailed crocheting the entire set and everything in it, including the people and the cat. When working in production, things move fast and can change quickly. Being able to work on the fly to come up with creative solutions is imperative. Before this project, I had never crocheted any sort of tailored garment, so when I agreed to the job I knew it would be a challenge. All in all, the commercial turned out great and I found that I have a knack for this type of excitement.

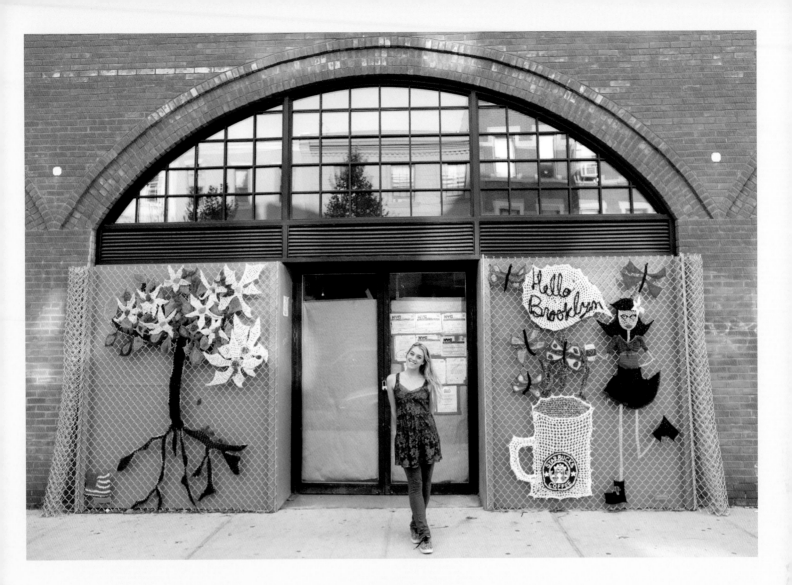

# starbucks

## WILLIAMSBURG, BROOKLYN

Starbucks hired me to create a piece of art on a fence outside a new store they were building in Williamsburg. It was a living mural that would grow and evolve over the course of one month. I added crochet elements every few days until the entire fence was yarn bombed. I started with the coffee tree and led the process all the way to the coffee bean. The final element was a coffee cup with the Starbucks logo. I also learned a bit of Starbucks trivia during my process. Because Starbucks originated in the seaport city of Seattle, the founders decided to name the coffee stores after the American classic *Moby-Dick*. Starbuck was the name of the first mate on the ship. Greek mythology has it that sirens lured sailors to an island in the Pacific, so the Starbucks founders used the siren as a logo to lure coffee lovers into their stores.

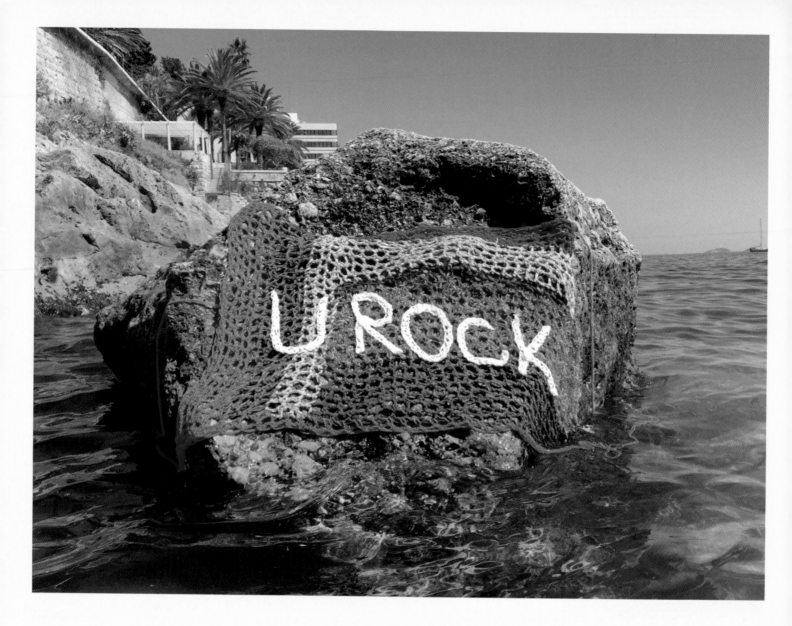

# u rock

## DUBROVNIK, CROATIA

I was in Croatia on vacation after filming *The Amazing Race*. I really needed to recuperate from my one-month race around the world. I couldn't pack yarn and hooks for the show, and this was the first yarn bomb I made after taking a month off from crocheting. Croatia was paradise, with warm breezes and beautiful blue water. I spent most of my time exploring caves and swimming—and crocheting. I couldn't wait to install this yarn bomb on the slippery rocks of Dubrovnik. Wading through the water with crochet in hand cemented the fact that I love what I do.

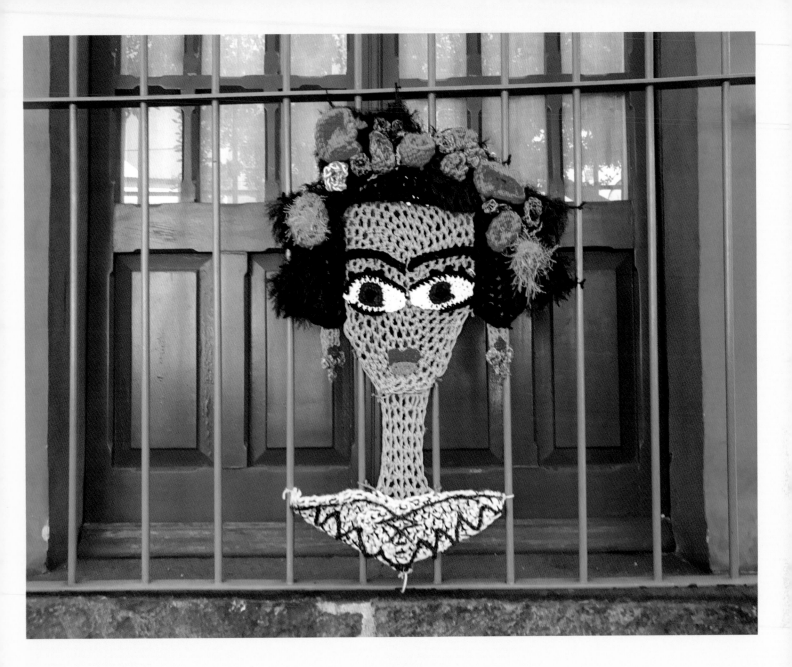

# frida

**MEXICO CITY, MEXICO**

This photo was taken in front of the Blue House at the Frida Kahlo Museum. When I traveled to Mexico City, I knew I was going to visit this special home-turned-museum, so I prepared a crochet portrait of the iconic artist before my plane took off from New York. I enjoyed crocheting the flowers in her hair and her big eyebrows most of all.

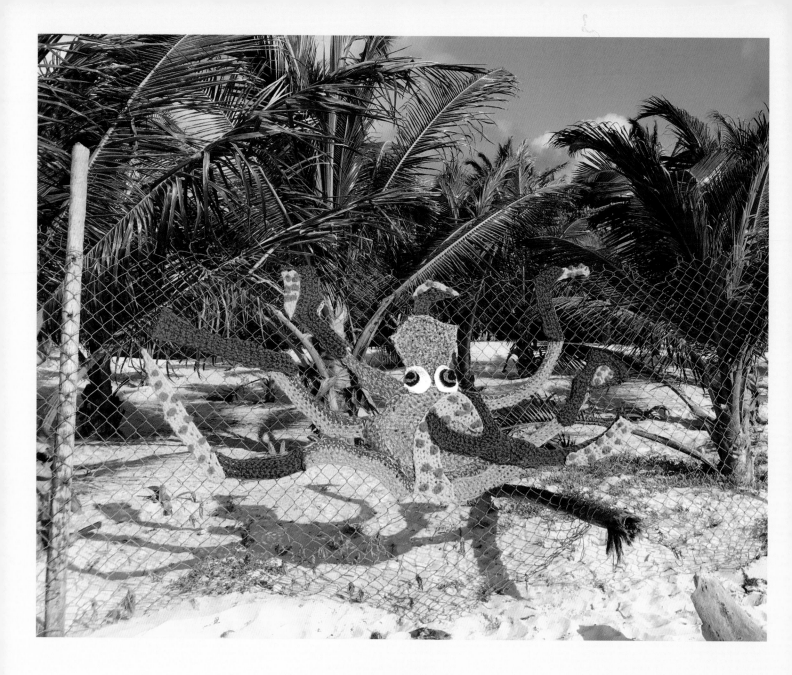

## octopus

### TULUM, MEXICO

The octopus is one of my favorite animals because of the hypnotic way it moves and the multicolored pigments in its skin. I hung this octopus on a chain-link fence on the beach in Tulum. Whenever I travel to foreign countries, I look for opportunities to incorporate my art within natural environments that I would not necessarily find back home.

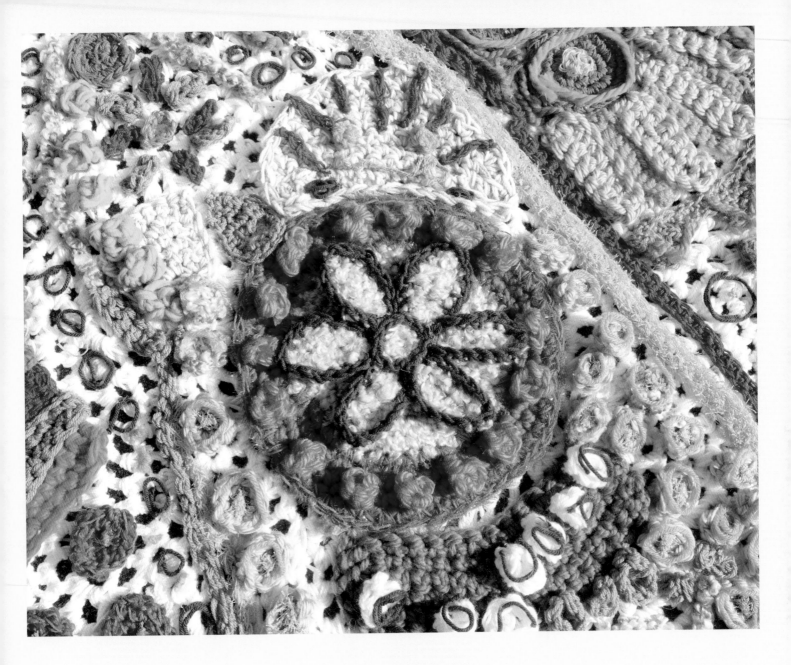

# art miami

**MIAMI**

Every year at Art Basel, artists and art enthusiasts from around the world gather together to celebrate all that is new in art. I was honored to create a piece for Art Miami, a show that features original works from world-renowned artists and annually coincides with Art Basel.

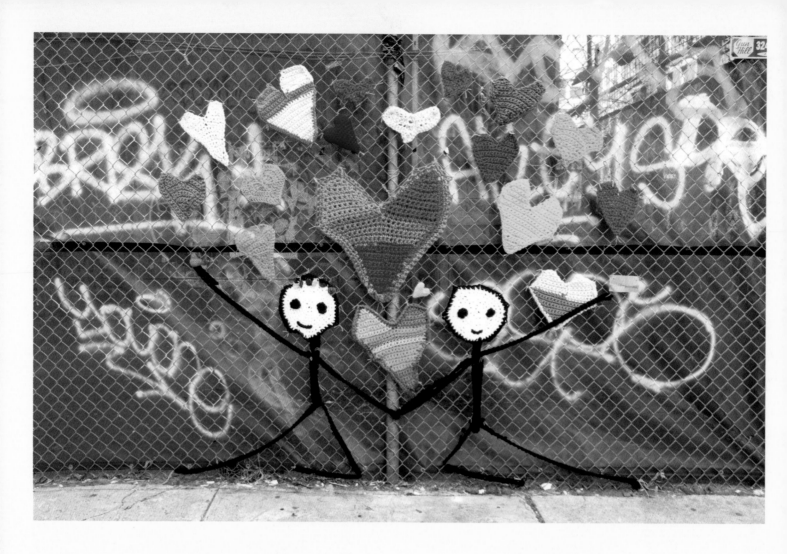

## foster pride

SOHO, NEW YORK

I immediately felt a connection with Foster Pride, an organization that teaches girls in the foster care system how to crochet and turn their creations into profit. I bought my first car with the money I made selling crochet scarves, so it was a real joy to meet these girls and share some of my crochet and business tips. We even yarn bombed on the street. The girls made all the hearts, bringing even more joy and life into the piece.

## mondrian

SOHO, NEW YORK

Every time I see this classic Yves Saint Laurent Mondrian dress, it reminds me of my grandmother. She loves the primary colors—red, yellow, and blue. Whenever I need help picking a color palette, she is my go-to gal. I hung up this piece for her in Soho, the fashion capital of New York City. The crochet girl stayed up on the fence for more than two months. I consider that a long run for a piece of crochet street art that was hung in such a prominent place.

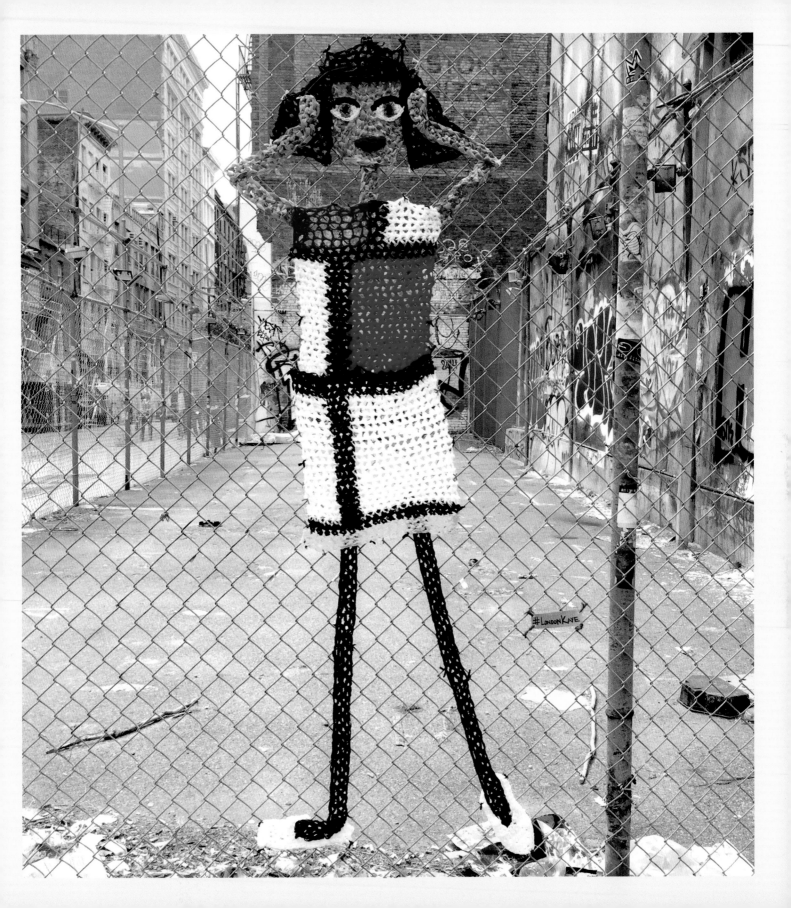

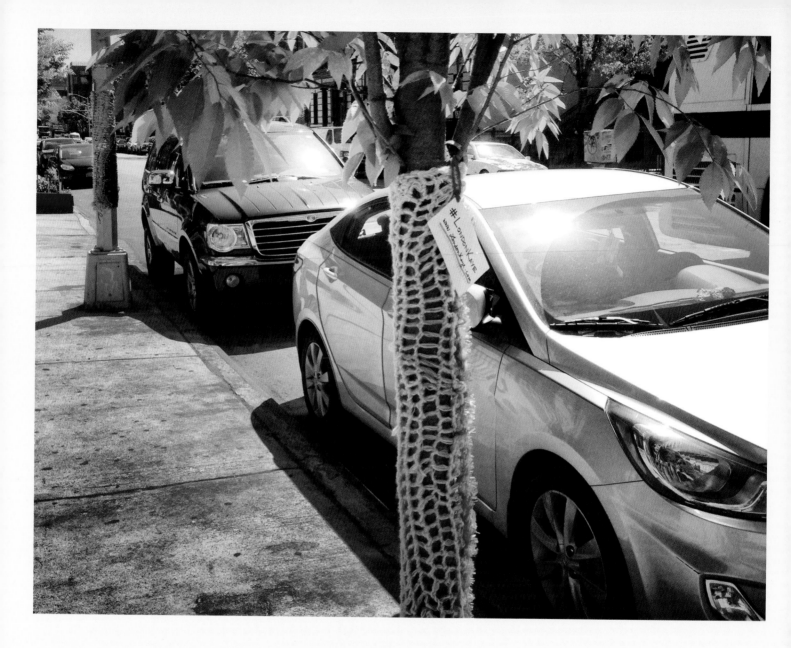

# first tree

### BEDFORD-STUYVESANT, BROOKLYN

This is the first yarn bomb I ever installed. I was living in Bed-Stuy and just walked outside and wrapped the first tree I saw. I don't think I would be the artist I am today without the support of the Bed-Stuy community. They have always acknowledged and protected my work, and I am grateful. Over the years, the tree has been so accepting of the wrap that it completely absorbed the yarn.

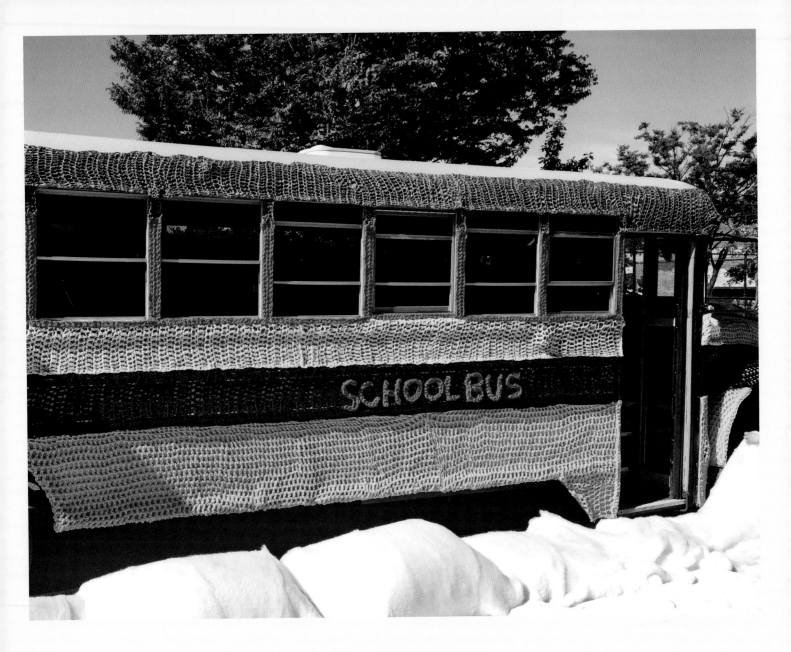

# gap school bus

**BROOKLYN**

I tend to say yes to projects first and then figure out how to execute them later. The strategy usually works well, but this Gap commercial really put me to the test. Transforming a school bus is no small task with only one week of lead time. I had a moment about midway through the process where I thought I would not be able to deliver on time. After a few deep breaths, I reminded myself that I am doing what I love. Every challenge is worth overcoming to be able to continue along this journey.

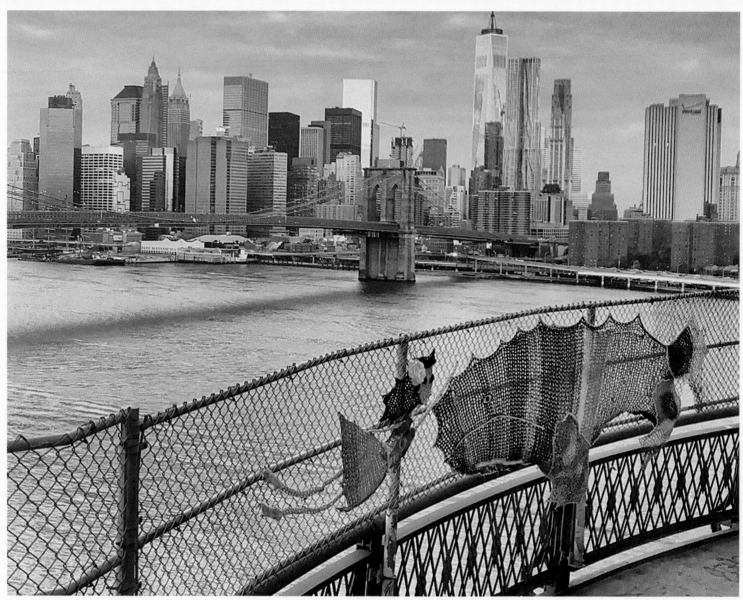

# whale dance

## MANHATTAN BRIDGE, NEW YORK

To this day, I still get butterflies in my stomach when I hang art in public spaces. The anticipation of not knowing who is around, how it will go, and if I will be stopped is exciting and nerve-racking. For this yarn bomb, a camera crew filmed me for a documentary on yarn. I was wearing a microphone and they were recording every word, which made me even more timorous. In these situations, my solace is to trust my work and have faith that things will always turn out better than expected.

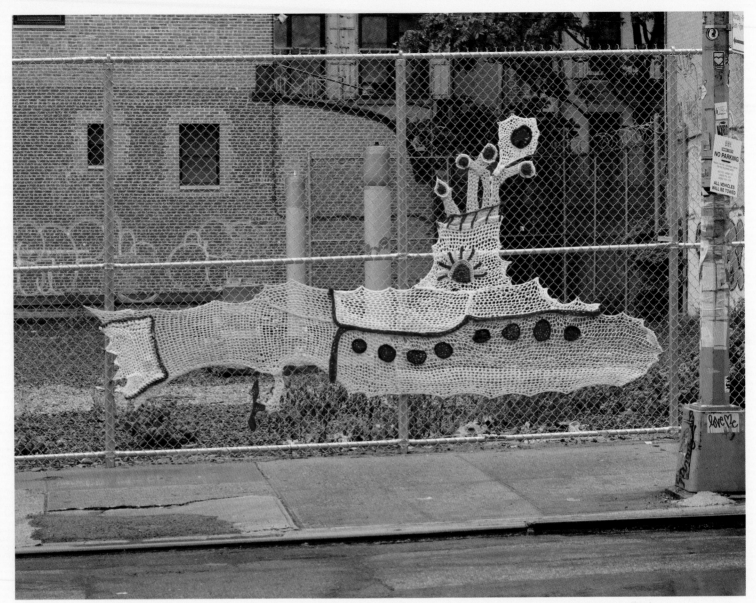

# yellow submarine

### LOWER EAST SIDE, NEW YORK

I hung this yarn bomb in the pouring rain while wearing all yellow, down to the shoes. I even slipped on a delicate 3-D-printed eye mask to go along with the whole ensemble. For a very short time, I thought it would be fun to disguise my face when I installed yarn bombs around the city. The idea did not stick, but it sure made installing this giant yellow submarine a moment to remember.

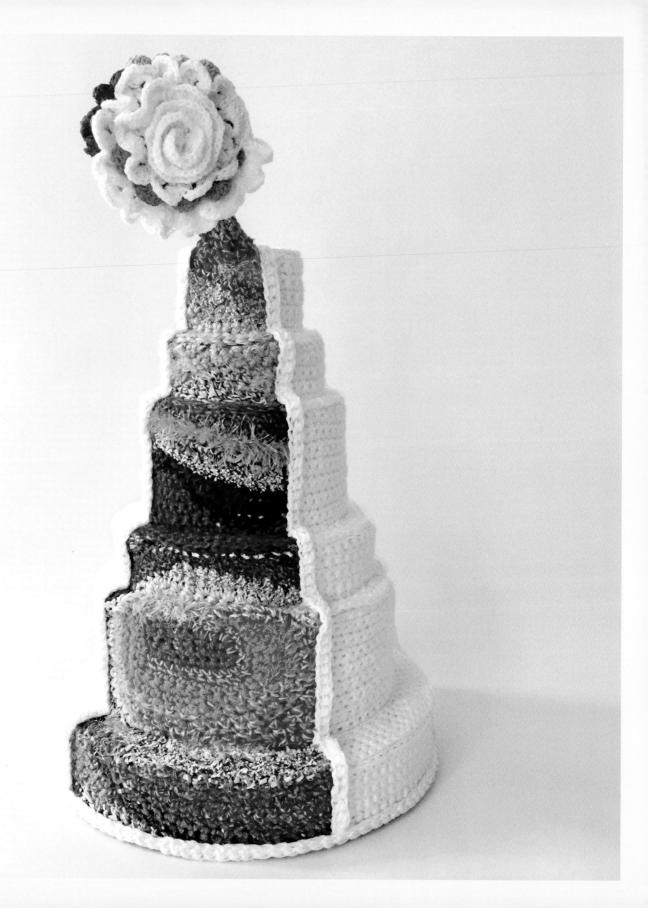

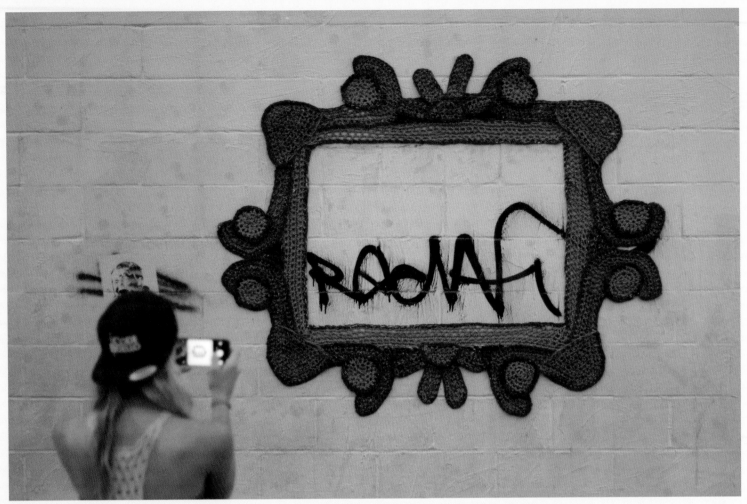

## cake

### RON BEN-ISRAEL CAKES, NEW YORK

This project was more of a challenge to crochet than I had expected. It wasn't about the three-dimensional shape, but rather what to do with it. I wanted to make something unique and meaningful. Since I had the time, I made three versions of this cake before I chose this particular design. One was more flamboyant, the other more traditional, and this one just right. Coincidentally, the day I put this cake together at the Ron Ben-Israel showroom, gay marriage was legalized in all fifty states.

## frame

### BUSHWICK, BROOKLYN

Through the years, I have learned a few dos and don'ts to keep in mind when putting up art in public places. One of the most important is: Never cover anyone else's art, tag it, or mark it with your own work. Even if you do not consider it beautiful, it is not OK to cover it up. I crocheted this frame around a classic graffiti tag as a subtle commentary on this unspoken rule of the street.

**yarn bombs**

151

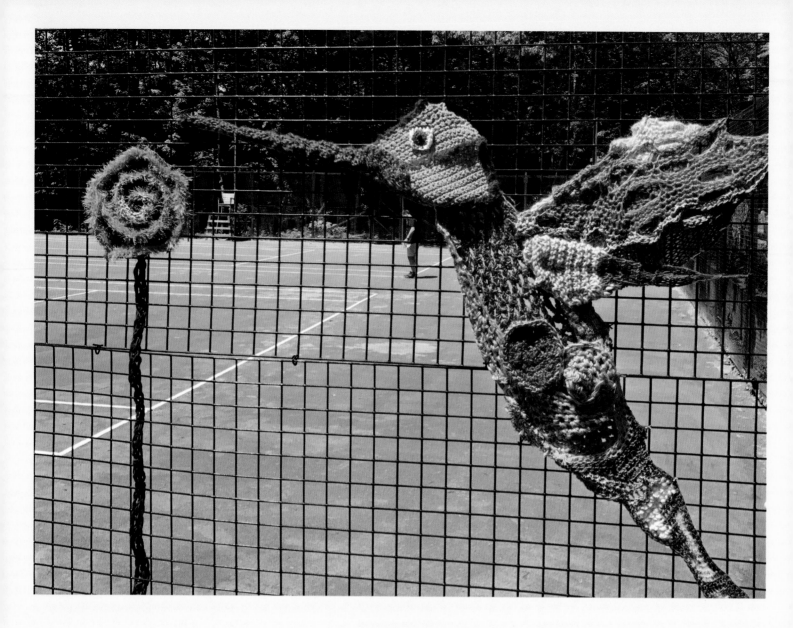

# squam

## CONCORD, NEW HAMPSHIRE

Squam Lake is a magical place where yarn enthusiasts come together to learn, share, and relax. I drove to Squam from New York City to teach a two-day workshop on yarn bombing. Being out in nature was a nice touch to this trip. I expected that because I was going as a teacher, I would not have the same experience as the participants. However, it was the complete opposite: I made lasting friendships, relaxed by the lake, and even learned to knit. I think I will stick to crocheting, but it was fun to become a beginner again and pick up something new. The yarn bomb above was made by one of my students.

# the telus health brain project
# in support of baycrest

**TORONTO, CANADA**

I was honored to be one of a group of artists who each contributed a brain sculpture to be displayed across Toronto for The TELUS Health Brain Project. The event is an outdoor exhibit that brings together art, philanthropy, and science to raise awareness and funds toward Baycrest's fight against Alzheimer's and other related dementias.

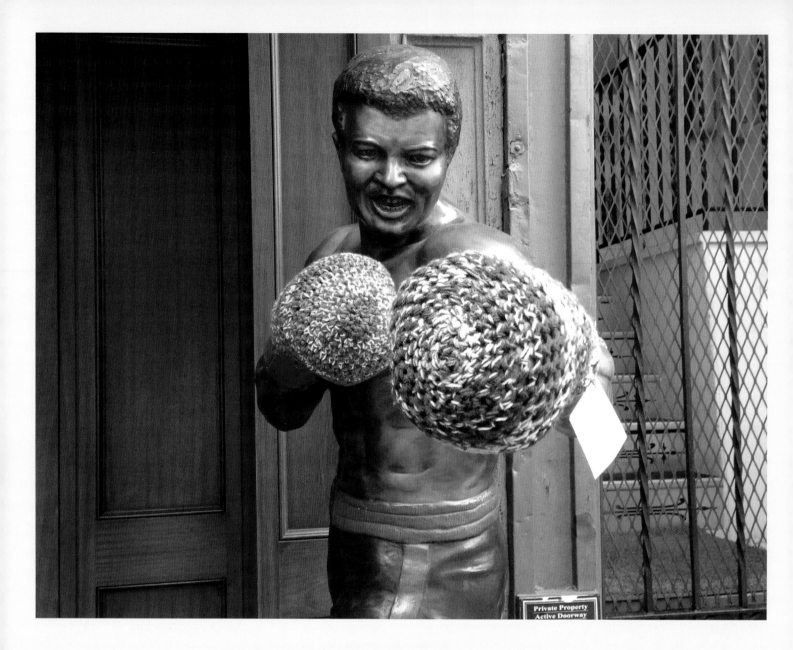

# ali statue

## MEATPACKING DISTRICT, NEW YORK

I thought it would be ironic to turn one of the strongest fighters into a softer figure by adding a touch of crochet to the Muhammad Ali statue on West 14th Street. To make his gloves, I reached into my crocheted scrap pile and found two beanies I had made. The colors looked good together, and I had a feeling they would stretch to fit the statue. This was the eighth yarn bomb I ever made, and it still holds the record for the fastest project from start to finish.

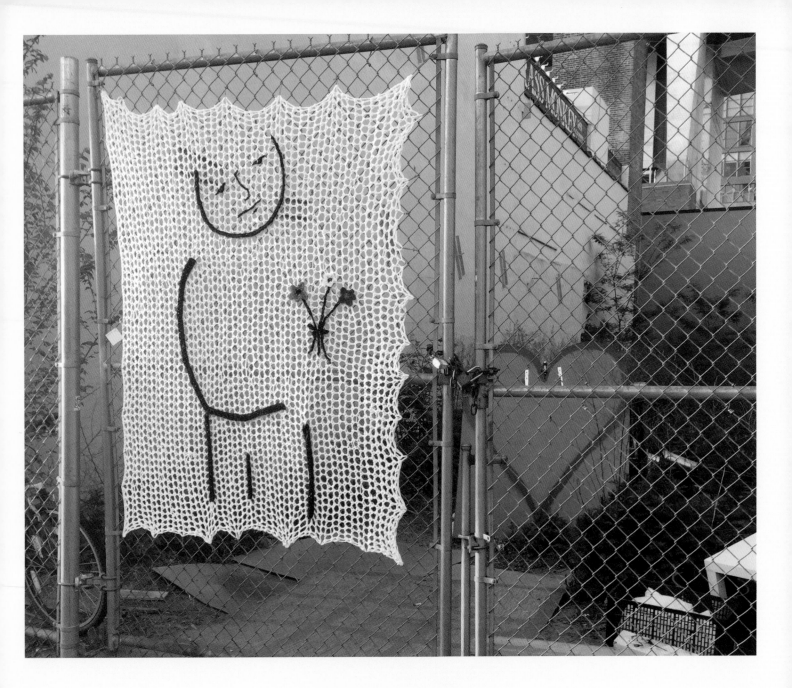

# mother's day

**MEATPACKING DISTRICT, NEW YORK**

My mom is an artist, and one year for Mother's Day I transformed one of her sketches into crochet. I have always been inspired by my mom's art because of the way she makes lines move on a canvas. She uses simple shapes to create larger pictures, and I mimic that approach even though I use a different medium.

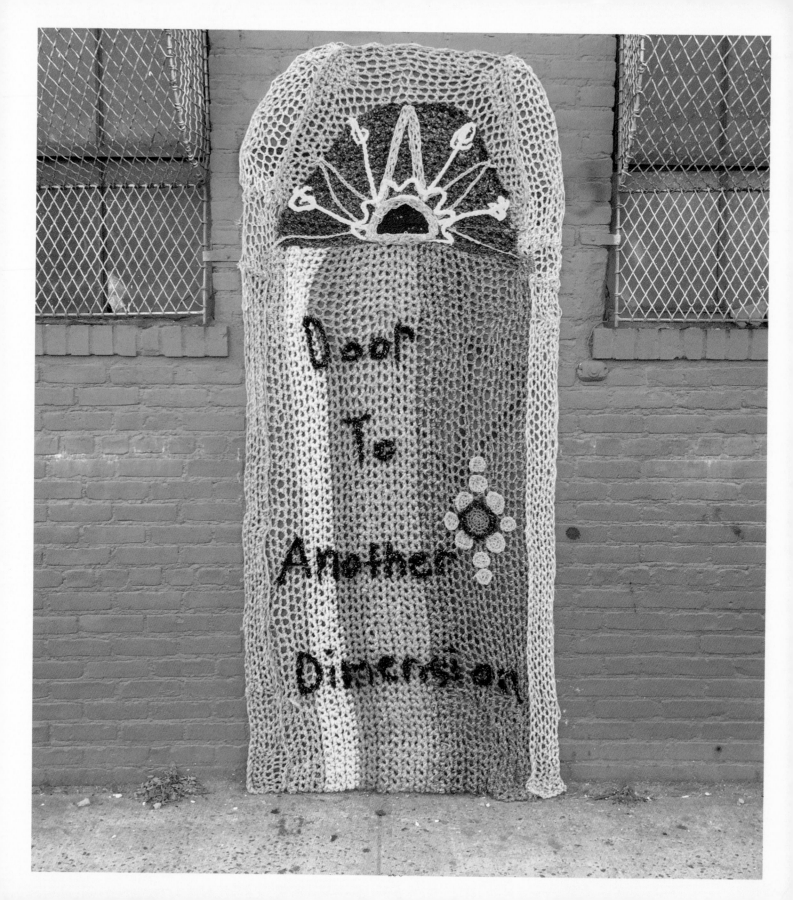

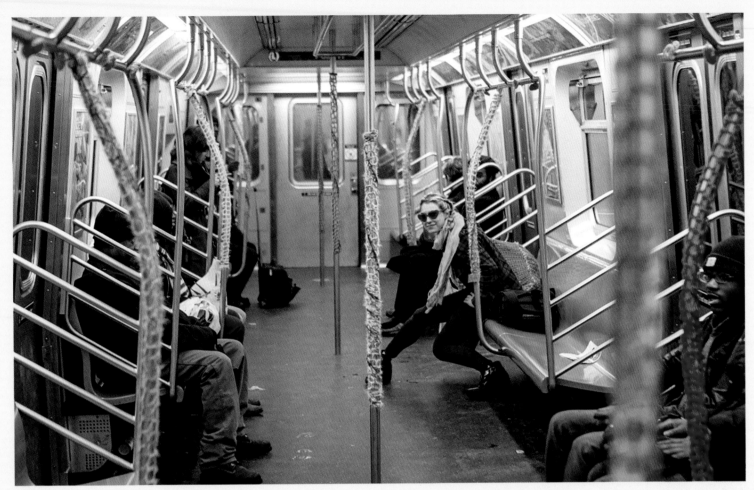

PHOTOGRAPH BY AYMANN ISMAIL

## door to another dimension

**BROOKLYN**

Even though it was 15 degrees Fahrenheit outside, I knew it was going to take only thirty minutes to put up this piece. In situations like this, I bundle up with boots, scarf, hat, and all. My fingers have to be nimble, so I wear basic cotton gloves and cut out the fingertips. When it gets too cold, I put hand warmers in my pockets and take a few minutes to warm up when my digits get numb.

## L train

**L TRAIN, NEW YORK**

On Valentine's Day morning, I was determined to yarn bomb subway poles in crochet. I worked a full shift at the Apple Store before I hit the subway that night. I had crocheted during every break and at lunchtime, so I had enough crochet pieces to ensure a smooth yarn bombing process. It could not have gone better. I was greeted with only happiness and smiles. It took me two hours to cover every pole in the car and tie up hearts throughout. The crochet stayed up only a couple of hours before it was gone, but it was meant to be seasonal.

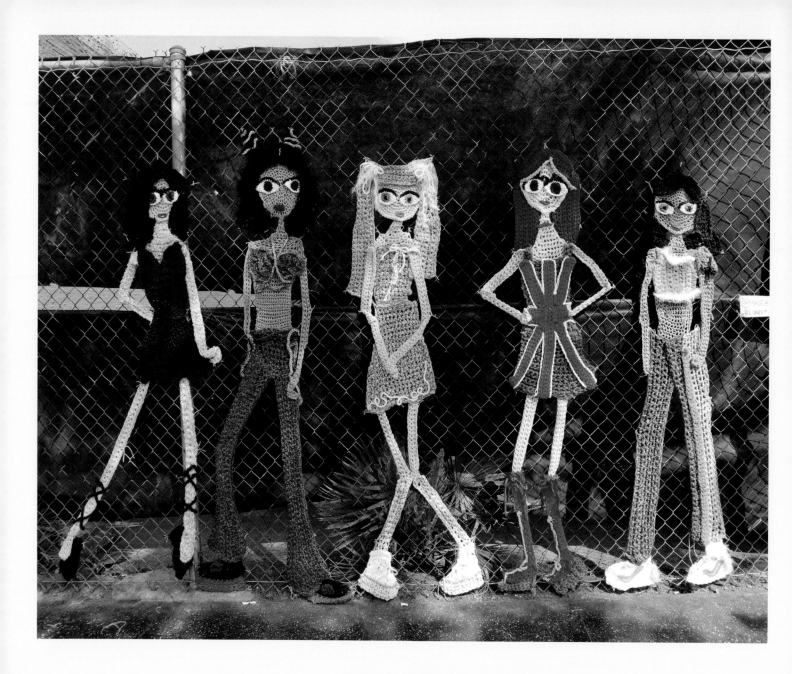

# spice girls

## HOLLYWOOD BOULEVARD, LOS ANGELES

I loved the Spice Girls when I was young—not just their music, but also their look. Their distinct fashion and personalities make for a great yarn bomb. As I was crocheting each girl, I spent a lot of time working on the detail in their clothes to reveal each individual style and point of view. This is my tribute to Girl Power!

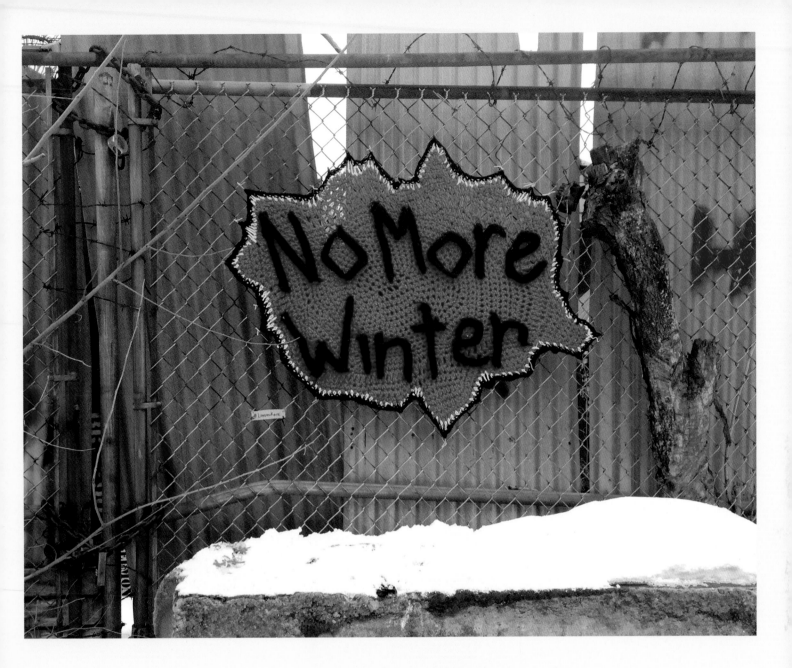

# no more winter

**BUSHWICK, BROOKLYN**

I made this at the tail end of one of the longest winters, now known as the polar vortex. I remember it well, because it was the first time my hair froze into icicles when I stepped outside my door. It was a treacherous season, but since then I have found another meaning in these few words. As our planet continues to get warmer, what lies ahead?

# carvana hauler

**PHOENIX, ARIZONA**

This hauler was used to make car deliveries to Carvana customers throughout the holiday season. I knew going into this project that the hauler had to be wrapped in a way that was durable enough to survive driving on the streets and freeways for a month. I worked with Carvana to develop a specific digital design that I used as a guide while crocheting, which included specific measurements of the entire hauler to crochet the base. The last step was adding appliqués and ornaments layered on top. This hauler got a lot of holiday honks as it drove around the country.

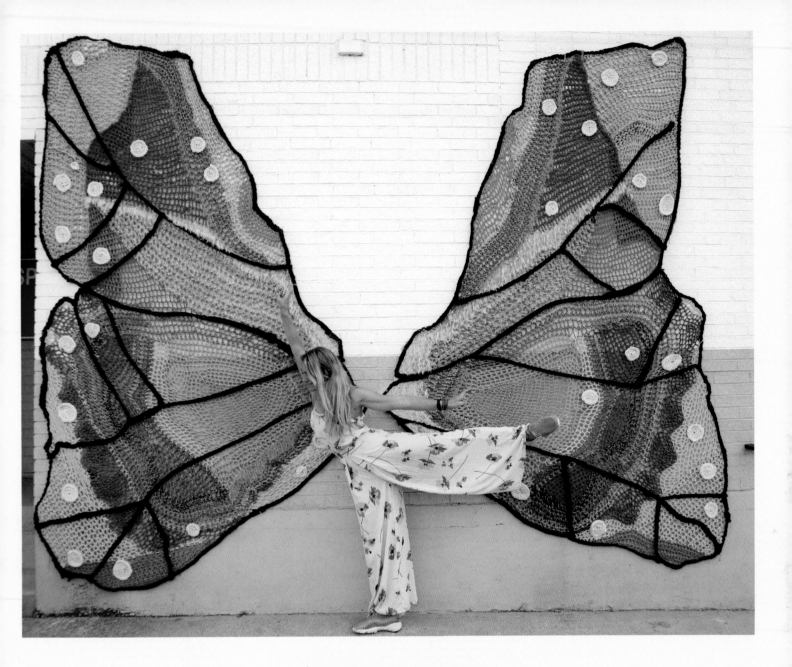

# butterfly wings

**FORT WORTH, TEXAS**

This piece is more than 11 feet (3.5 m) tall and spreads over 15 feet (4.5 m) wide. It was about noon when I started hanging these massive butterfly wings. It was just my sister and me when we started. By the time I was finished that night, a DJ was playing, food trucks had parked, and shops were staying open late. Hundreds of people came by to watch and support the street art being added to their community.

# drake devonshire

## PRINCE EDWARD COUNTY, CANADA

Prince Edward County is one of the most beautiful places on earth, blending together the water and the land seamlessly. I was asked to yarn bomb support beams on the site of a new Drake Hotel being built in Devonshire. It was my first crochet job outside the United States. I packed up all the yarn that would fit in my suitcase and jumped on a plane. At the time, I was reading *The Artist's Way* by Julia Cameron, and I was on the chapter where we are told to trust our own perception. I kept repeating that mantra to myself as I worked nonstop over the next three days. As it turned out, I had brought just the right amount of yarn in perfect colors to get the job done.

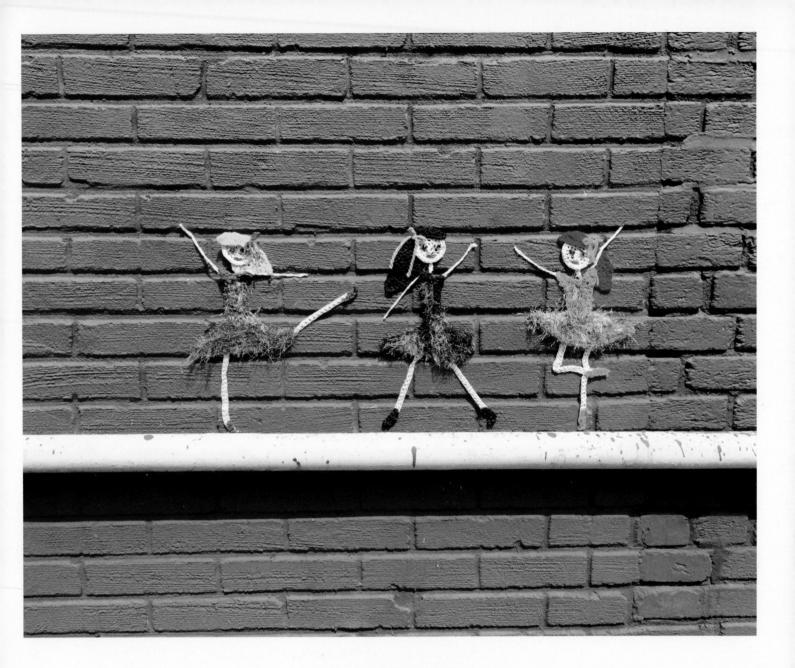

# tiny dancers

## BROOKLYN

This wall was right outside my apartment, and every time I passed by, I thought about what it would look like to see little crocheted people standing on it. In contrast to my normal approach to yarn bombing, I used my smallest hook instead of my largest. There are different techniques that go into crocheting on such a small scale. It's a bit out of my comfort zone, but sometimes that is where the magic happens.

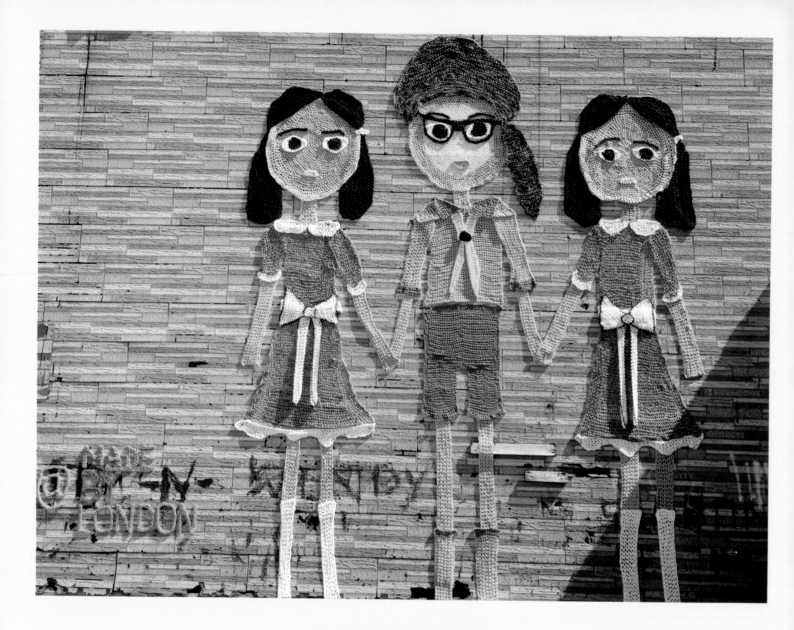

# holding hands

## BUSHWICK, BROOKLYN

When I asked about putting up a large piece of art on the wall at my neighborhood flea market, I was given the thumbs up and jumped at the opportunity! However, I didn't know I had asked the wrong person for permission. After spending months of crocheting and days installing, the actual property owner told me he did not want the crochet there anymore. This misunderstanding generated a discussion about gentrification in Brooklyn that was much larger than my art. I learned a lot through this experience because I got to see firsthand how art can start an important conversation.

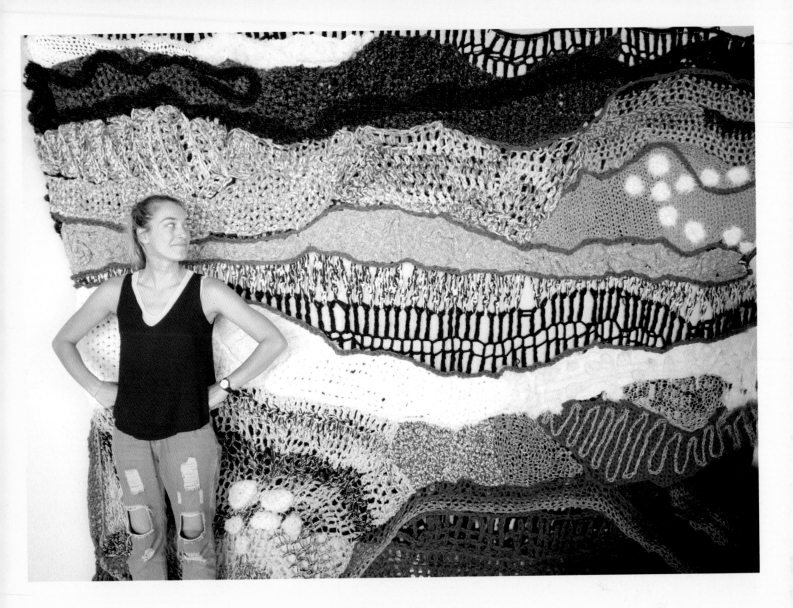

# canada goose

## NEW YORK AND TORONTO

For this piece, I was inspired by the shape of a geode and the way the shades of gray blend together. I pieced together swatches I had crocheted in a meticulous way, giving thought and attention to the placement of each one. About three days before I had to put the finished piece in the mail, I realized I had read the required dimensions incorrectly—it was supposed to be three times as big! I was in California at the time, so I brought in my mom and sister as reinforcement to help get the job done. We spent the next couple of days working with very little sleep, transforming the original piece I had spent months on into something even more magnificent.

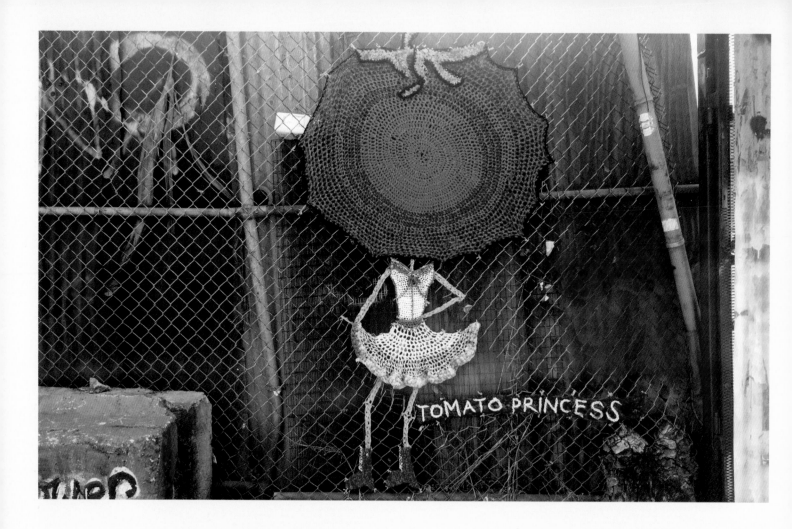

## tomato princess

**GOWANUS, BROOKLYN**

I have very strong feelings for my Tomato Princess and the whimsical spirit she exudes—so much so that I actually took her down from the fence only hours after hanging her up. I did not want a random passerby to snatch her up. The irony is that I have a deep disdain for the taste of tomatoes. The Tomato Princess message is to turn something you hate into love. It wasn't until a couple of months after I originally took her down that I had enough courage to hang her up once and for all. FYI: I still won't eat tomatoes.

## progressive

**SANTA MONICA, CALIFORNIA**

Progressive Insurance came to me looking for a crocheted version of the famous Flo. They wanted to document my process and share it on social media. To make sure the crocheting was captured in the most entertaining way, I used time-lapse video to record it all—from crocheting the pieces to hanging it on a chain-link fence.

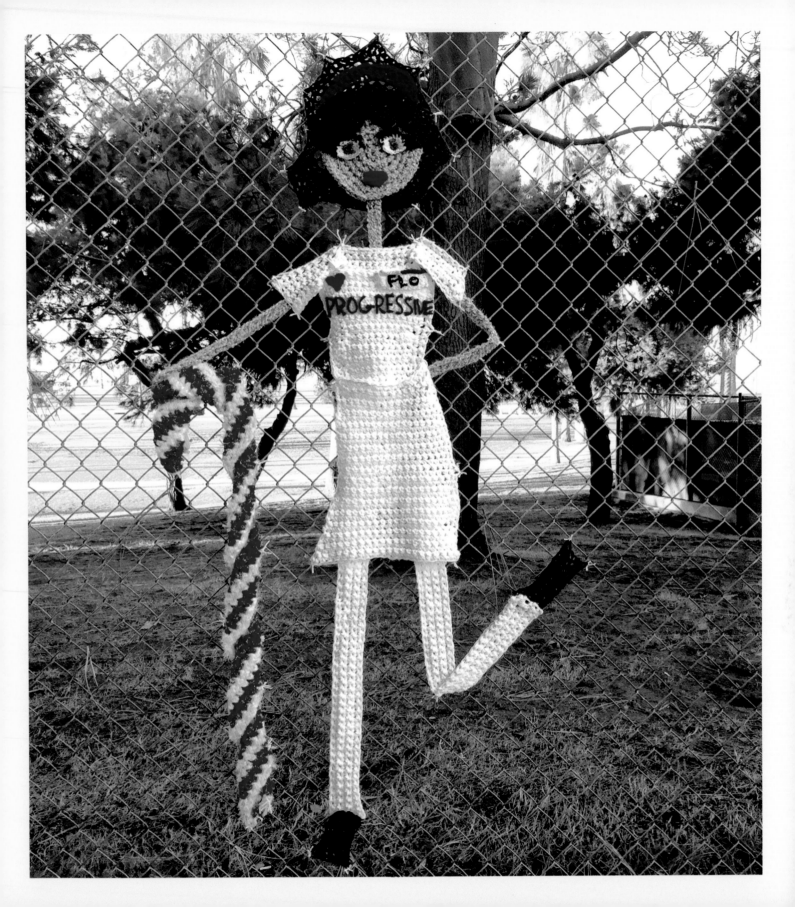

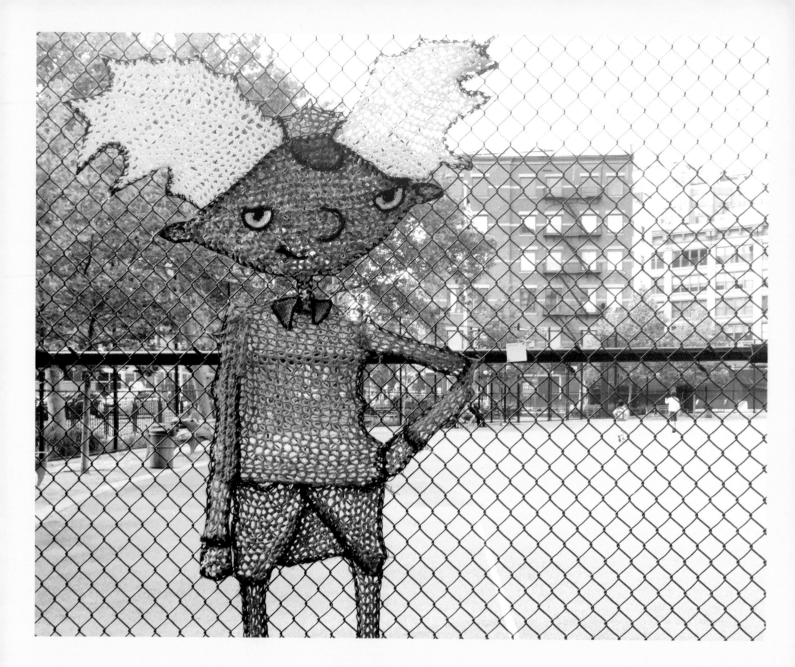

# hey arnold!

## WEST VILLAGE, NEW YORK

*Hey Arnold!* was one of my favorite shows. He is the original hipster, and he lived in New York City long before I did. I moved to the city for college at age eighteen, and if not for my friends and my first-generation iPhone with the built-in map, I don't know if I would have made it more than six months. I hung up this piece after living in New York for six years. I still don't have Arnold's New York City swagger, but I'm getting closer.

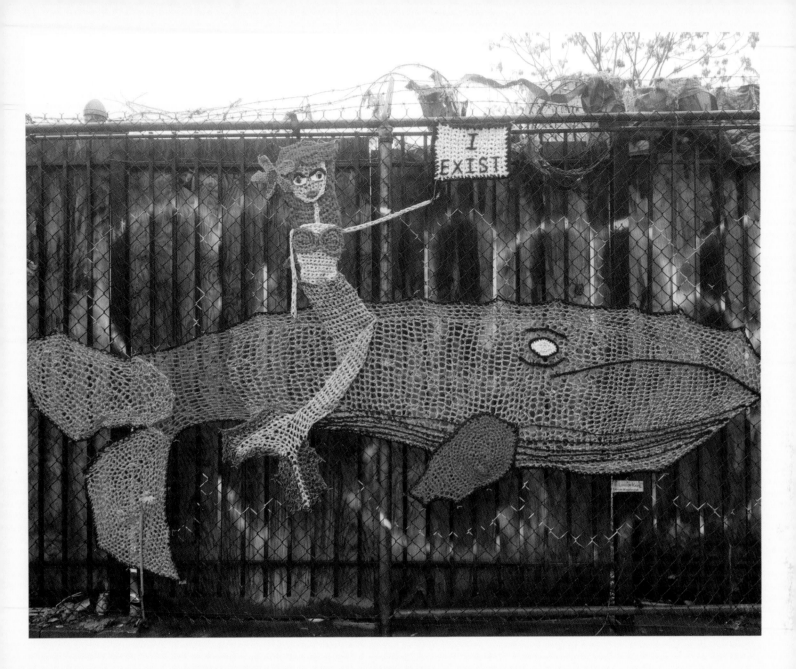

# i exist

**BUSHWICK, BROOKLYN**

I hung this piece up on my twenty-sixth birthday. It was a time of transition in my life when nothing felt comfortable. On this day, the one thing that grounded me was hanging up this yarn bomb. It stayed up for about a year—just before my next birthday.

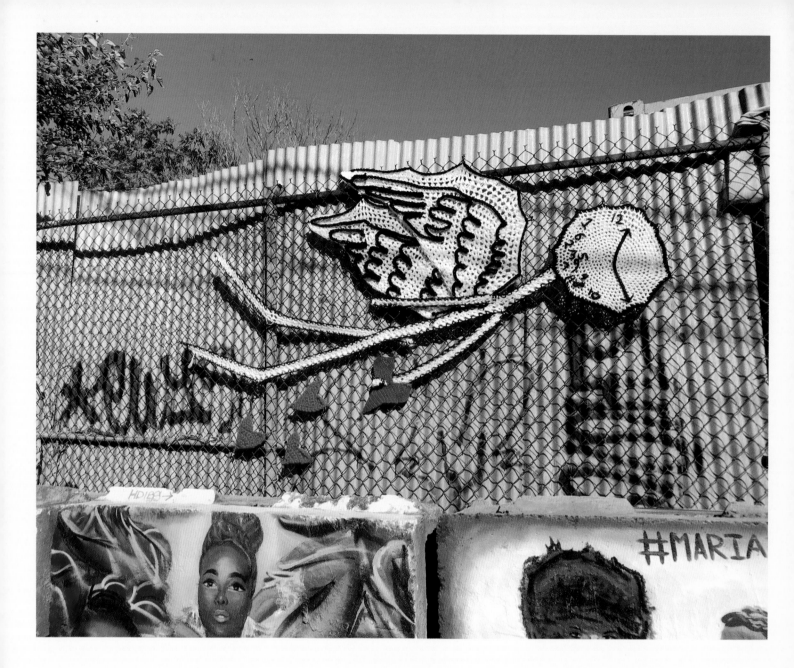

# time flies

## BUSHWICK, BROOKLYN

I no longer live in Bushwick, but it will always be the landscape of a very special time in my life. I made this piece specifically for this fence, at this time. I hung it up after I no longer lived there as a way to connect myself and my art with the neighborhood.

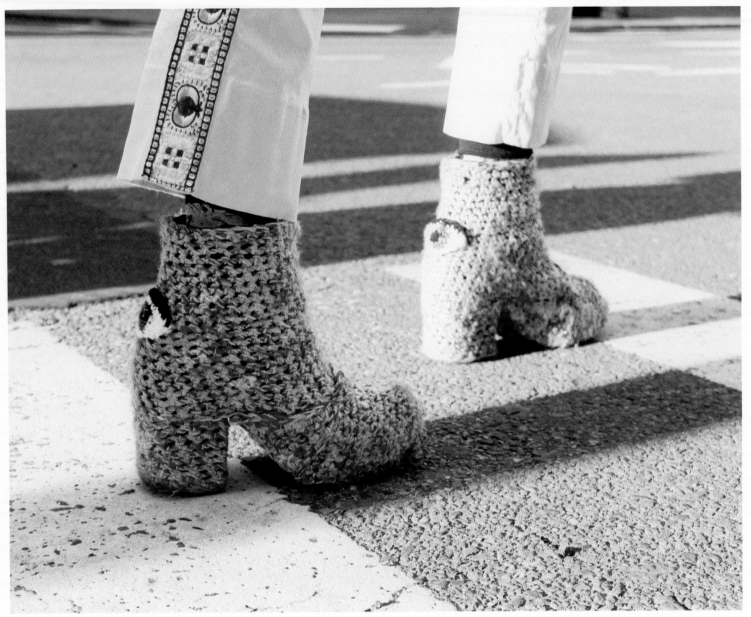

# crochet boots

## SOHO, NEW YORK

The first time I rocked this pair of boots was in the dead of winter in New York City. They kept my feet warm and the snow out. I used a multicolored yarn from a specialty shop at Vogue Knitting LIVE. It was hand dyed, one of a kind, and very expensive. It is rare that I have time to crochet for myself, so when I crocheted these boots, I knew exactly which yarn to use.

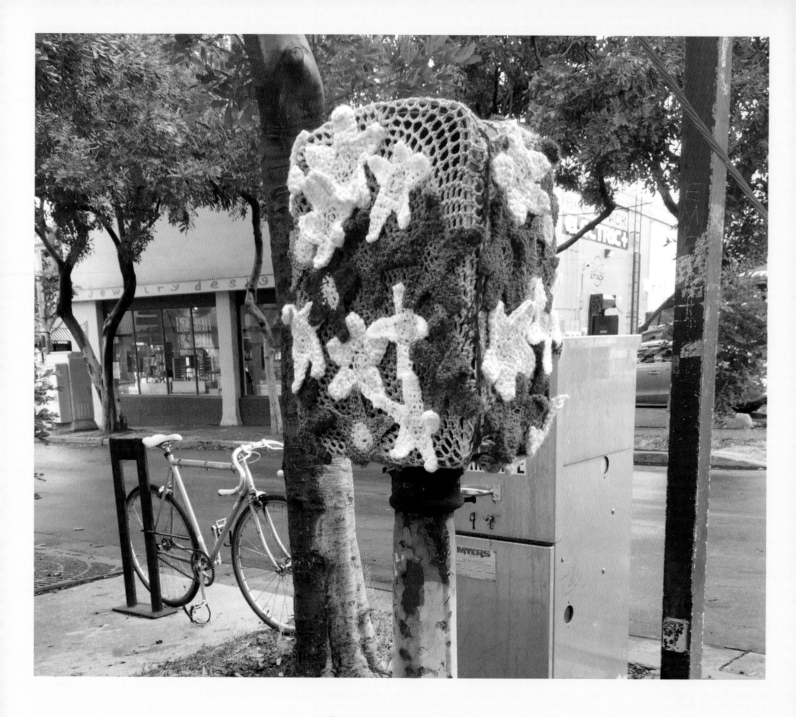

# flower power

**SANTA MONICA, CALIFORNIA**

I covered this pay phone in flowers, and after only a couple of days it was gone. Not only was the crochet gone, the actual pay phone was missing as well. To this day, I do not know what exactly happened here.

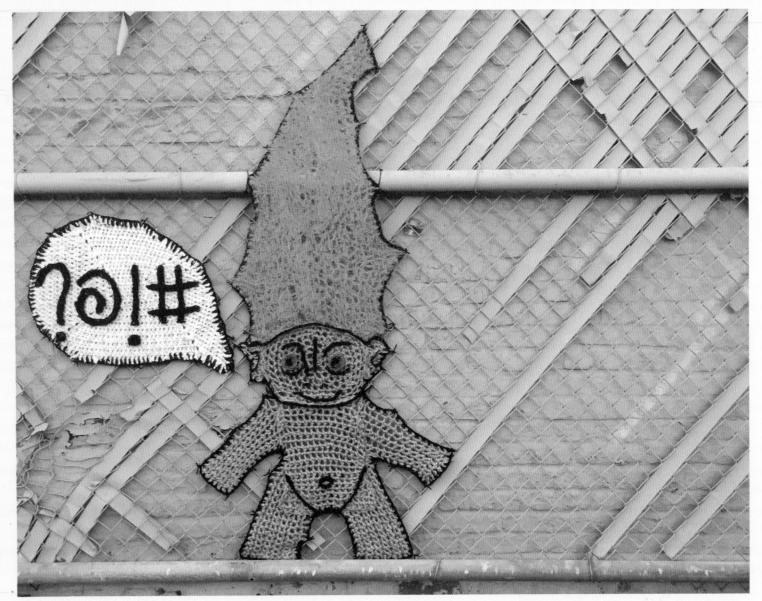

PHOTOGRAPH BY JOHN PATE HAMILTON

# troll doll

## BUSHWICK, BROOKLYN

For a time, a piece of my art was at the center of a conversation that was drawing a lot of press. Because of that, internet trolls took to my social media to speak their minds. I crocheted this troll as a way to process what was going on. I had never encountered such negative feedback, so it took a lot of work not to let it affect me. The furor lasted about two weeks, and then suddenly it stopped. It was as if something else had magically shifted everyone's attention in another direction.

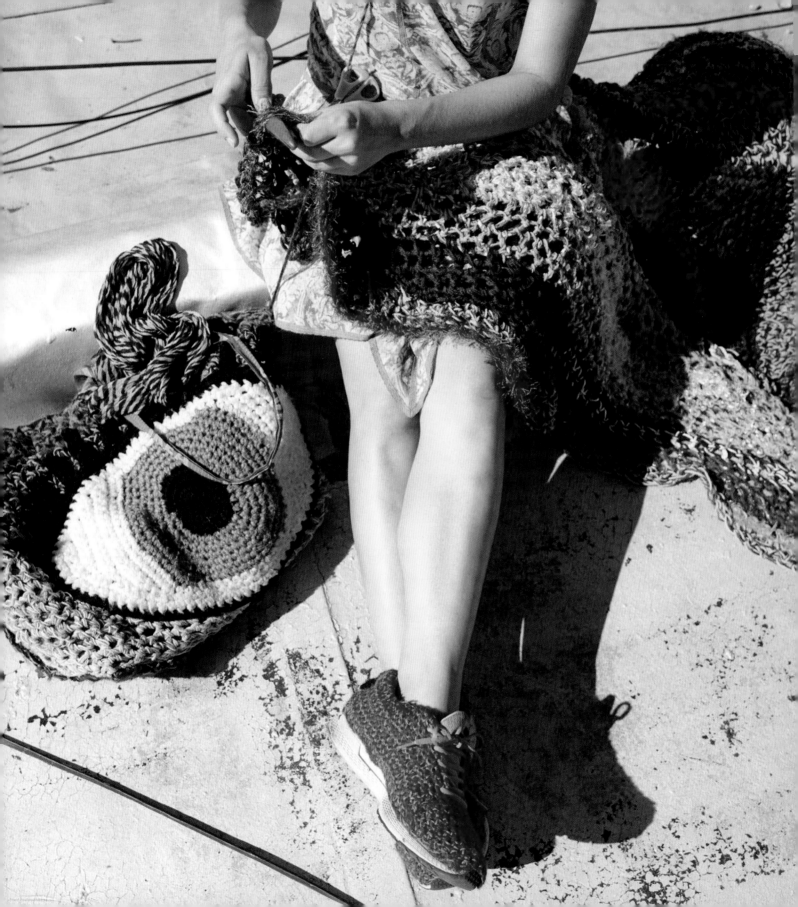

# ABOUT THE ARTIST

London Kaye is a street artist and designer based out of Los Angeles and New York City. Her unique use of crochet has attracted international attention from major media outlets, globally recognized brands, and an engaged following on social media. London created a line of yarn with Lion Brand Yarn and received a patent for her original crochet hook design.

Stories on London and her work have been featured in the *New York Times*, on *CBS This Morning*, and in more than one hundred other publications and news events. From a billboard in Times Square for Miller Lite to the windows of REDValentino, Starbucks, Disney, and more, London has worked with the A List of brands. To this day, and true to her street art roots, most of her pieces are hung on fences in public places around the world.

London received her BFA in dance from New York University's Tisch School of the Arts. After graduating, she set out to make the world a better place by making people smile. She realized that her lifelong passion for crochet could be the perfect avenue to achieving this goal. In the years since this discovery, her creative and colorful style has brought smiles to people everywhere, and she has built a dedicated fan base that is excited to see what will come off the crochet hook next.

# ACKNOWLEDGMENTS

I would like to thank the following people for helping to make this book come to life. First, to everyone at Abrams. Thank you to my editor, Meredith Clark, for making this process delightfully seamless and for believing that yarn bombing is worth writing about. Thank you to Danielle Youngsmith, designer; Lisa Silverman, managing editor; Katie Gaffney, production manager; Deb Wood, art director. This book would not be possible without all of your thoughtful input and help every step of the way. Thank you, Mike Slebodnik, for capturing the photos in this book and making the yarn shine in every shot. Thank you to Chase, Evan, and Roxy for contributing so much love and support throughout this process and helping turn my vision into a reality. To my talented crochet team, for making large projects with a quick deadline something to look forward to. To Carolynn, for teaching me to crochet with ease and confidence. A HUGE thank-you to my family and loved ones for expecting me to have a bag of yarn with me at all times. Thank you for being my biggest fans and sharing your thoughts, advice, words of love, business tips, and creative input. And finally, a special thank you to my parents, Kevin and Kaysie, for always pushing me to follow my dreams. Without you, I would not have had the courage to be who I am today.

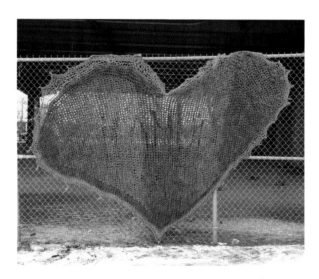